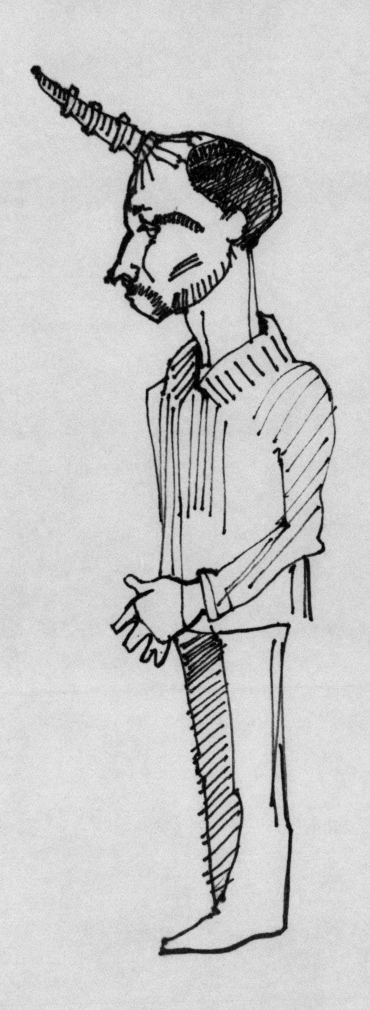

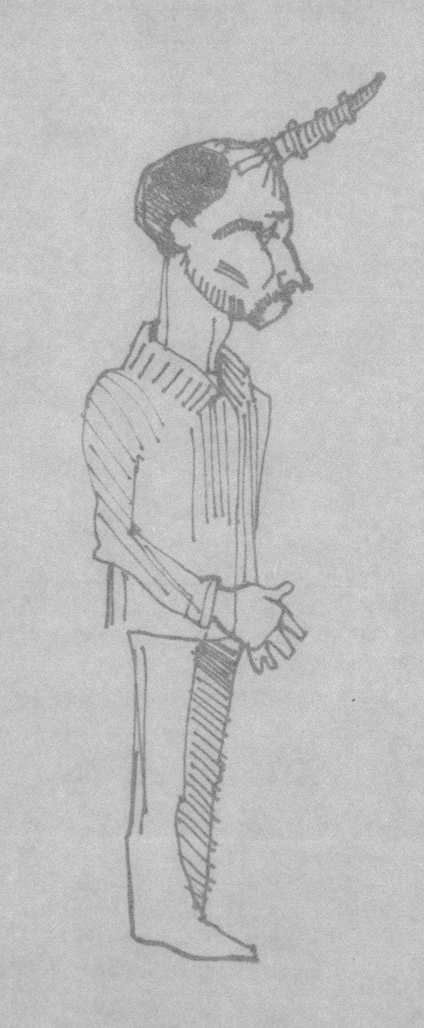

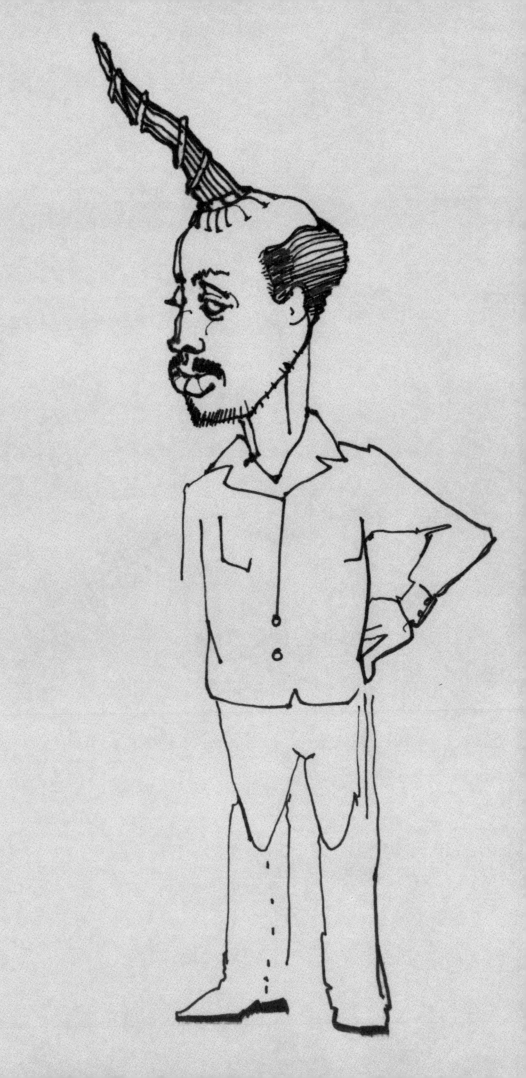

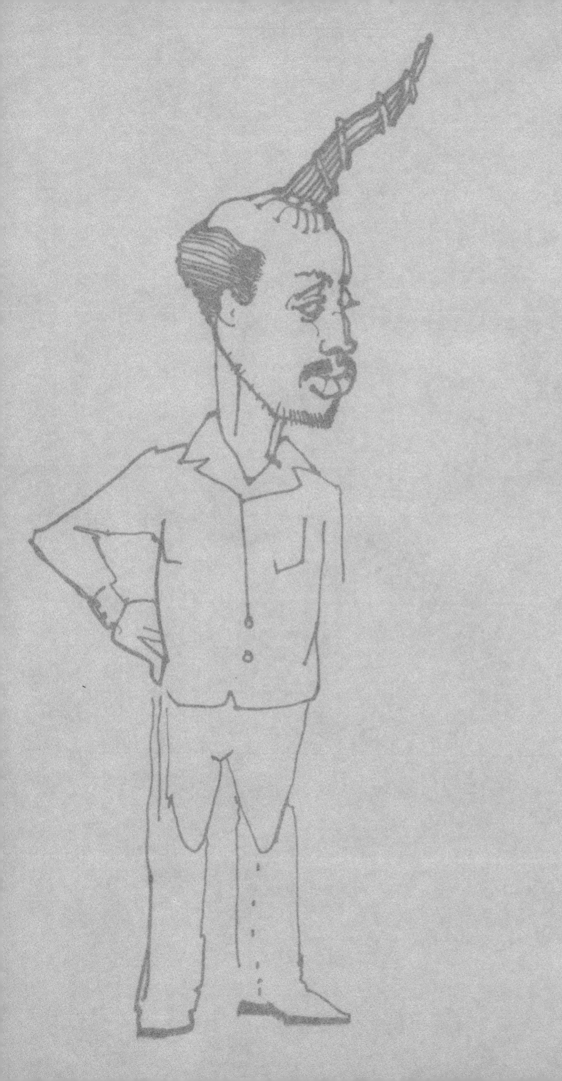

THE UNICORN INCORPORATED
CURTIS R. BARNES

EDITED BY JO-ANNE BIRNIE DANZKER

FRYE ART MUSEUM

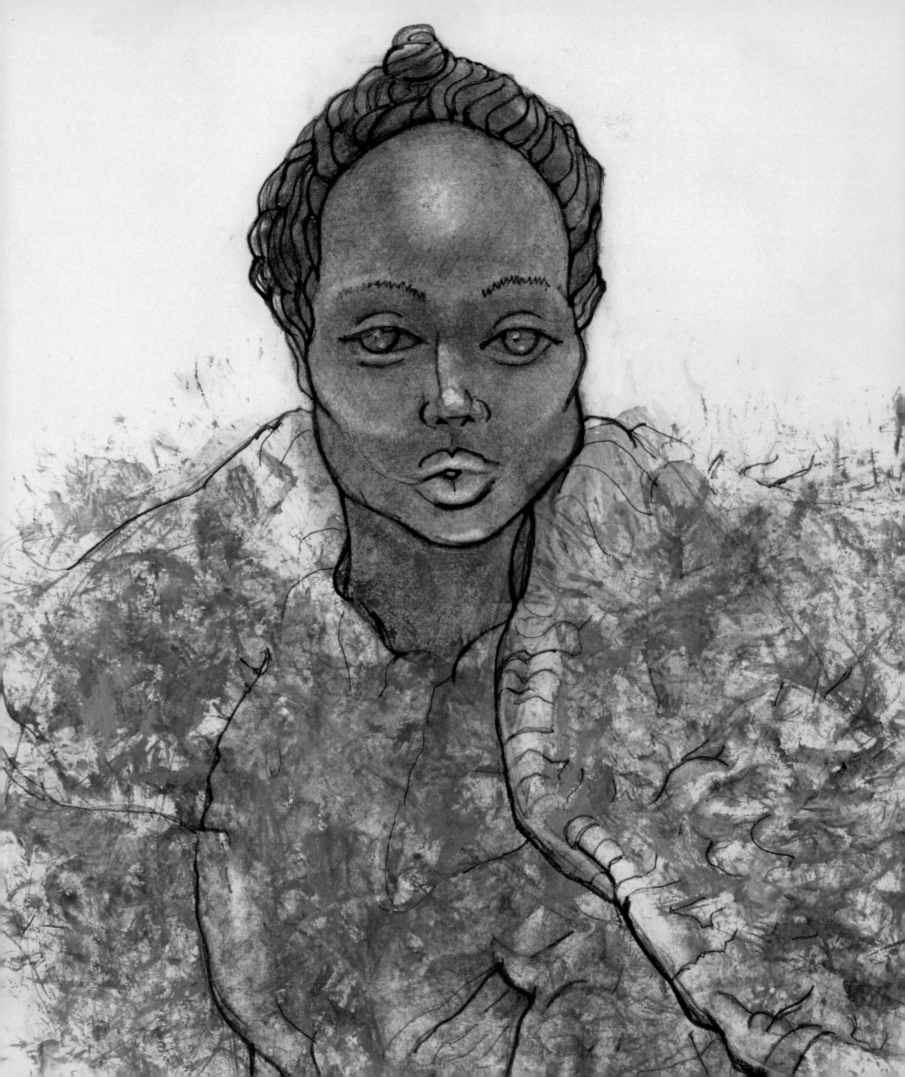

Curtis R. Barnes is a storyteller. We all are, he says.

He writes compulsively, with his wrist, in cursive and in pictures. His all-too-real fables come in a single frame and peel off masks and disguises. We are predatory, he believes, under a thin layer of civility.

For Barnes, home is a spiritual place where self-determination and living responsibly are prerequisites. Then, and only then, land is alive and family and ancient traditions are present. Only then is it possible to live with some actionable measure of integrity.

Barnes' imagination is limitless and includes unicorns that are African in origin. They fly and have special powers; they are a metaphor for men of color.

He has a head full of paintings, primarily of people of color, which includes everyone.

The distinguished musician Ishmael Butler writes in this volume of listening to a Curtis Barnes. When I listen, I hear the Dionysian and shards of the Apollonian (the peaceful, contained, nonpolitical canvas he intended but did not paint). Dissonance, fracture, error, and damage abound.

We are grateful to Curtis Barnes for the extraordinary generosity with which he has shared his work and his deeply held beliefs. Maikoiyo Alley-Barnes, his son, has been an invaluable guide during the production of this exhibition. We are similarly grateful to Ishmael Butler, for listening to "lines [that] make shapes and sense of this place."

The Frye Art Museum collections and curatorial team has brought excellence and dedication to the documentation of hundreds of works of art and archive materials, and to the preparation and installation of the exhibition. Special acknowledgment is made of project coordinators Tina Lee and Amelia Hooning, registrar Cory Gooch, collections assistant Jess Atkinson, exhibition designer Shane Montgomery, and exhibition preparators Mark Eddington, Ken Kelly, and Elizabeth Mauro. The support of Scott Lawrimore, deputy director, collections and exhibitions, throughout this complex process is deeply appreciated.

The present volume has been made possible through the exceptional contributions of the publications team of the museum under the expert guidance of Jeffrey Hirsch, deputy director, communications. I would like to recognize publication coordinators Tina Lee and Amelia Hooning, designer Victoria Culver, copyeditor Laura Iwasaki, and proofreader Roberta Klarreich for their outstanding work. Our collaboration with Hemlock Printers, especially Peter Madliger, vice president, prepress, and Susan Bernauer, account manager, has been exemplary.

Ishmael Butler writes eloquently of inhaling the works in this exhibition *knowingly*, of remembering who we are, for us, in us, and about us.

This is the gift of Curtis Barnes to us all.

Apartheid, from the
Mask series, 1984
Pen, ink, and opaque
correction fluid on paper,
mounted on graph paper
12½ x 8½ in.
Collection of the artist

4

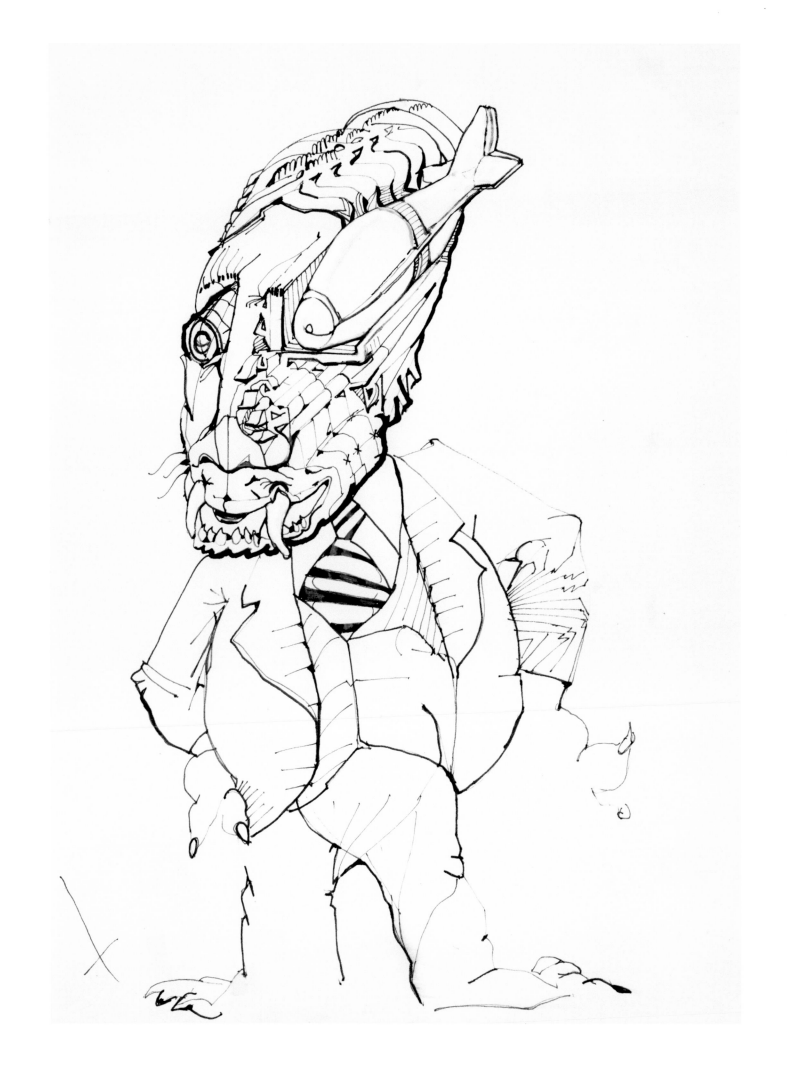

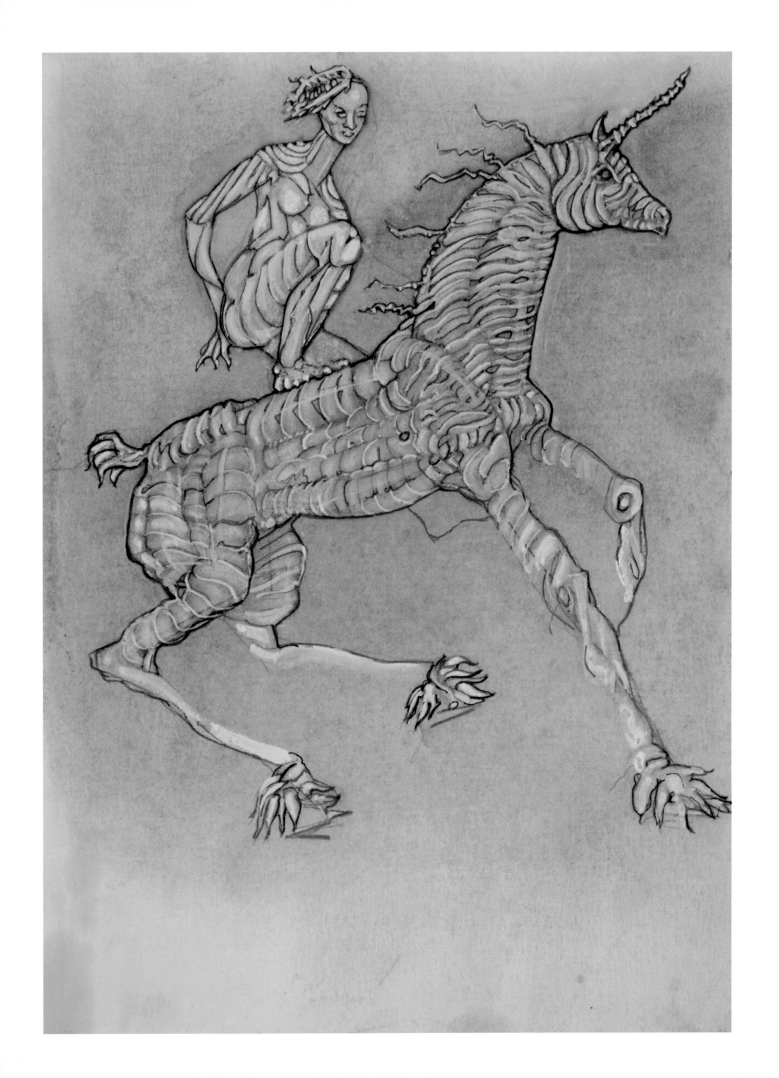

i lay on a bed wrapped except my eyes in a heavy coarse gauze. my arms legs and heart casted. i know that i can move but something unseen and blank is discouraging it. looking around my mind casts questions about the space . . . "a sepulchre." the thought nibbles at the hook. somewhere below beside or inside me i can hear water fall, crash and pool and then fall again then stream.

this repeats. a rhythm is established. above me, the ceiling is a swirling of oxblood clouds in a pale blue expanse, a sky. a flock or herd (heard) or a richness of serpo-avian-equestrial beasts is moving across or up the sky; languid, muscled and powerful, a cerulean vein. i hear the declaration of their breathing and the heavy pad of their hoof-paw-claws in advancement. this, meshes with the falling water, and a groove is pronounced.

something nectar scented floats up next to me, someone, her. my blood sets to hurry. her hair is threads of melting gold twisting around each other, making whirlpools. her dress a sheer azure gauze. her flesh making shapes of the material, knolls and drifts meadows intrigues.

"feeling like you i see." this stated observation is sung. her voice is the lushest sound or form of petals and nautilus and mists growing from itself into space, into me. my eyes tear a bit and squint at her in question. she shoots an instructive glance down toward the lower me. i follow it. my wet eyes widen. i see my legs loose now of the hard white cast and gleaming bronze. moving jubilant to a beat. we split a laugh.

"what happened to me?" i ask.

"they did, happened to all of us" matter-of-factly.

i inhale, knowingly. i'm silent for some long time, regarding. she holds or drops something or it hovers. a square rich with lines. potent lines. lines that run and turn sink and soar whisper and yell. lines of happy moans joy cries definite lines sure lines. these lines make shapes and sense of this place. listening to these lines move i remember who i am. for me, in me and about me these lines distinguish truth from reality. i am the truth.

i am standing up now. waving at her as she floats up the green horizon standing on a unicorn. i know what is mine to do.

Untitled, from the *Television in the Sky* series, 1984
Conté crayon with pen and pencil on paper
11 x 8½ in.
Collection of the artist

EARLY YEARS IN THE CENTRAL DISTRICT

I was born in Little Rock, Arkansas, in 1943. For a variety of reasons, my parents relocated to Seattle in 1945. Before I started grade school, my paternal grandmother came to stay with us in the Central District for an extended period of time. I was a preschooler, so she and I spent a lot of time together. During that time, while making quilts and preserves and performing other magic, she taught me how to read, count, and write in cursive, and she introduced me to Aesop's fables, a variety of folktales, mythology, and other make-believe worlds.

One day, my father, who had been working to help clean out the Yesler public library,[1] brought home a variety of discarded books. A lot of them had illustrations that fired my imagination and for some reason created a compulsion to draw. I have been drawing ever since. The Yesler library was a block and a half from my house, so I spent a lot of time there. Once the head librarian realized that I could read and write, she taught me how to find my way around the library, use the card catalogue, and she didn't restrict my book borrowing to the children's section of the library.

In retrospect, my childhood was rewarding and full. I was able to roam from neighborhood to neighborhood on foot or on my bike. I was expected and encouraged to find ways to fill my time. Once, when I told my father I was bored, he told me that was a personal problem I could resolve. There was no television. The primary forms of entertainment were reading, listening to the radio or recorded music, and attending one of the two neighborhood movie theaters. And of course there was an array of comic books, magazines, and comic strips.

ART CLASSES AT THE FRYE ART MUSEUM

I've been extremely fortunate in that I've always been encouraged and supported by my family. One of my elementary-school teachers mentioned a program of art classes for kids available at the Frye Art Museum to my mother at a parent-teacher conference, probably to discuss my tendency to spend class time daydreaming. So one day, my mother told me to gather up the drawings she had had me collect and we caught the bus, which was also her way to show me how to get back and forth to the Frye. We lived on Twenty-Second Avenue South, just south of Yesler, so it would have been a little too far to walk.

We met a woman at the Frye who had a conversation with my mother after she looked at my drawings. If the museum opened in 1952, I must have been eight or nine years old when I started classes. I wound up coming to the museum on a succession of Saturdays. It opened up a whole new world, a new terminology and technology. I liked the concept of art instruction, but art classes had to compete with other Saturday activities like playing ball, barnstorming, hanging out with friends, riding bicycles, etc. A lot of my Frye memories are happy. I remember the first time I came to art class I brought a set of oil paints my parents had given me the previous Christmas, possibly at the suggestion of the same

grade-school teacher. I remember being told that I didn't need to bring my oil paints again, that we weren't working with oil and wouldn't be for some time. I do recall my introduction to charcoal—charcoal sticks and drawing on large sheets of newsprint on easels, being told to "draw with my wrist," and the instructor coming up behind you, observing you and your work. Until then, at home and at school, I had bent over whatever I was drawing, tightly clutching a chewed pencil and using whatever kind of paper I had available.

At the Frye, we would draw still lifes. I seem to remember that the older students were able to draw from live models. Of course I wanted to be in the life drawing class, but I was told to be patient. Since I was taking the art class, I had open access to the art collection displayed at the Frye. I spent a lot of time just wandering around, looking, absorbing the artworks, amazed by the possibility that I could create artwork, too. Seeing works of art was an entry into a whole new world of magic. I will probably always remember the painting of horses fleeing a burning stable. The impact of seeing actual works of art was at least as significant as the art classes.

ART EDUCATION AFTER THE FRYE

Although I had been told that I was too young to use oil paints, I read the instructions that came with the set I had been given by my parents and taught myself. There was an art store next to the Greyhound bus station. I think it was called Seattle Art. In addition to having a wide range of painting, sculpture, and drawing supplies, they carried an extensive selection of how-to books, like how to draw and paint horses, color theory, perspective, anatomy, etc. Over the years, I invested some of the money I earned in art supplies and how-to books. The owner of the store was always informative and supportive.

Art instruction offered at the grade-school level was nonexistent. The art classes I took in junior high were more focused but still very rudimentary and not helpful, with the exception of the encouragement I received to enter the yearly scholastic art competition. At Garfield High School, on the other hand, actual art classes were taught by the feisty Ruth Nystrom. We had easels, and she talked about the vanishing point and the masters. By the time I graduated from Garfield, I was pretty much self-directed. Most of the subsequent art courses I took were out of curiosity and to satisfy degree requirements.

I enrolled at the University of Washington in 1961. By then I was leaning toward studying law or architecture, but I continued to take art courses. The University of Washington was another out-of-the-body experience, especially the book section in the old University Book Store, which is another story for another time. There are gatekeepers as well in the academic community, with its midcentury masquerades and rituals. Going to the University of Washington was like entering another world. It was intimidating, fascinating, and a surreal experience. How do you become a sociologist? How do you become an artist in that world?

During the mid-'70s, I enrolled at the Cornish School of Allied Arts in Seattle and graduated with a dual degree in painting and sculpture. In the late '70s, I also received a degree in wood technology.

THE 1960S

In 1964 I was drafted into the army, where I served until I was discharged in 1966. I was drafted just as American involvement in Vietnam intensified. I was entirely on my own, dealing with the reality of survival. The level of corruption and wheeling and dealing in the military was sobering, but again, a story for another time and place. At this time, there was also the stance of Muhammad Ali[2] and others, about whether or not they were willing to fight in a foreign war with conditions the way they were here in America. It was a time of serious decisions. Yes, it has had a profound impact on me and my subsequent work.

People tend to talk about the protest movements of the early through late 1960s as if this is when African American resistance began and ended, but it depends on your perspective. Throughout the 1920s, '30s, '40s, and '50s, there was a strong awareness of what was taking place. People were speaking about and calling attention to obvious realities. You could read about the lynchings and the mind-set and way of life depicted by southern, Euro-American writers like William Faulkner and Robert Penn Warren. Ralph Ellison, Richard Wright, and James Baldwin were actively writing at this time. During the 1920s, there was the Harlem Renaissance, with writers like Langston Hughes and visual artists like Jacob Lawrence, Claude Clark, and others. These currents were constant; it wasn't a curtain that suddenly went up. We would learn about the status of protest sitting around in the living room on Sunday afternoons. The older generation was talking about Paul Robeson[3] and the controversy about the statements of Jackie Robinson[4] and the debate between them about who was right and who was wrong. Resistance was and is an ongoing issue. People had different reactions to, and solutions for, what should be done. There were sharp differences. These dichotomies are not new and are ongoing and still reverberate within the community.

When I left the army, I moved to the Bay Area, which, in terms of social interaction, politics, and intensity, was a center of primary activity. The energy was magnet-like and infectious. I had every intention of remaining in the Bay Area, but a freak auto accident left me stranded in Seattle in 1971.

Even as a child, I was, and have always been, averse to and militant when confronted with the ongoing results of discrimination in whatever form it takes. By the time I returned to Seattle, I had become a never-ending, lifelong foe of institutionalized racism. No matter how you attempt to dignify, rationalize, or understand it, institutional racism is one of the lowest forms of human interaction. Put simply, it is utter bullshit. Race as we have come to know it is an artificial device created to disguise certain economic realities of the last five hundred years.

U$A, 1971
Drawing for *Afro American Journal* 4, no. 18 (April 8, 1971)
Pen and pencil on ledger paper
11½ x 17 in.
Collection of the artist

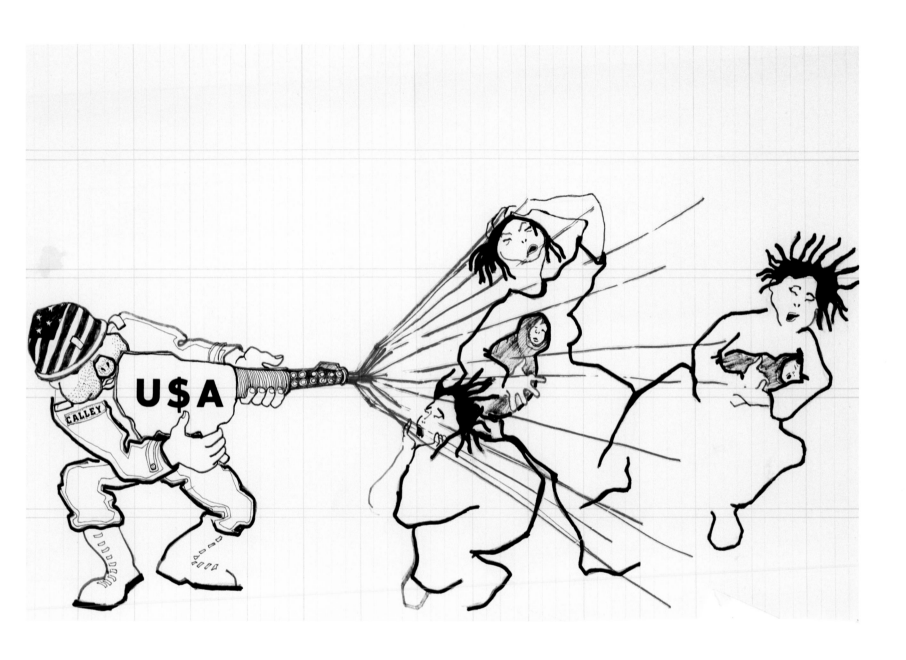

A CALL TO AWARENESS

The *Afro American Journal* was published in Seattle by a group of dedicated African American men who worked out of the Black House. Many of them were admirers of Paul Robeson. The editor was a very articulate, witty, talented man in his forties. The political agenda at the Black House was based on self-determination, control of the resources within the community, and reciprocity. Producing cartoons was my way of contributing to and supporting that philosophy. In time, the principal publishers joined the Nation of Islam, and the paper ceased publication.

Over the years, my subject matter has been classified as political. My cartoons were influenced by and responded to the cartoon work of artists from the *Black Panther* newspaper and *Muhammad Speaks*.[5] We would sit around, talk politics, and come up with a theme and suggestions for the cartoon. I'd go home and play with it. Some of the cartoons are in this exhibition: *White Seattle Is Doomed*, *Black Community*, *U$A*, *Seattle Public School System of Miseducation and Racism*, and *The SST*.

 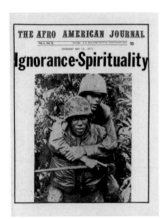

The African American community in Seattle was deeply divided at this time, and there was an active struggle between camps. There were those who argued for adherence to the nonviolent approach of Martin Luther King, Jr., while others supported the approach of Malcolm X. We didn't want there to be any confusion about where we were, so that drove the language and content of the journal. For me, a cartoon is one frame to get the message across, so I tried to be as straightforward, simple, and clear as possible. This was a serious endeavor that was reviewed by an editorial board. If a young man was shot by the police, then, yes, it was a call to awareness, an alarm. Police are public servants, so make them do their job. And if they can't do their job without destroying somebody, then maybe they shouldn't be there. That was the message.

Afro American Journal 4,
no. 14 (March 11, 1971)
11½ x 8¾ in.
Collection of the artist

Afro American Journal 4,
no. 20 (May 6, 1971)
11½ x 8¾ in.
Collection of the artist

Afro American Journal 4,
no. 21 (May 13, 1971)
11½ x 8¾ in.
Collection of the artist

Black Community, 1971
Drawing for *Afro American
Journal* 4, no. 19 (April 22, 1971)
Pen and pencil on ledger paper
11½ x 17 in.
Collection of the artist

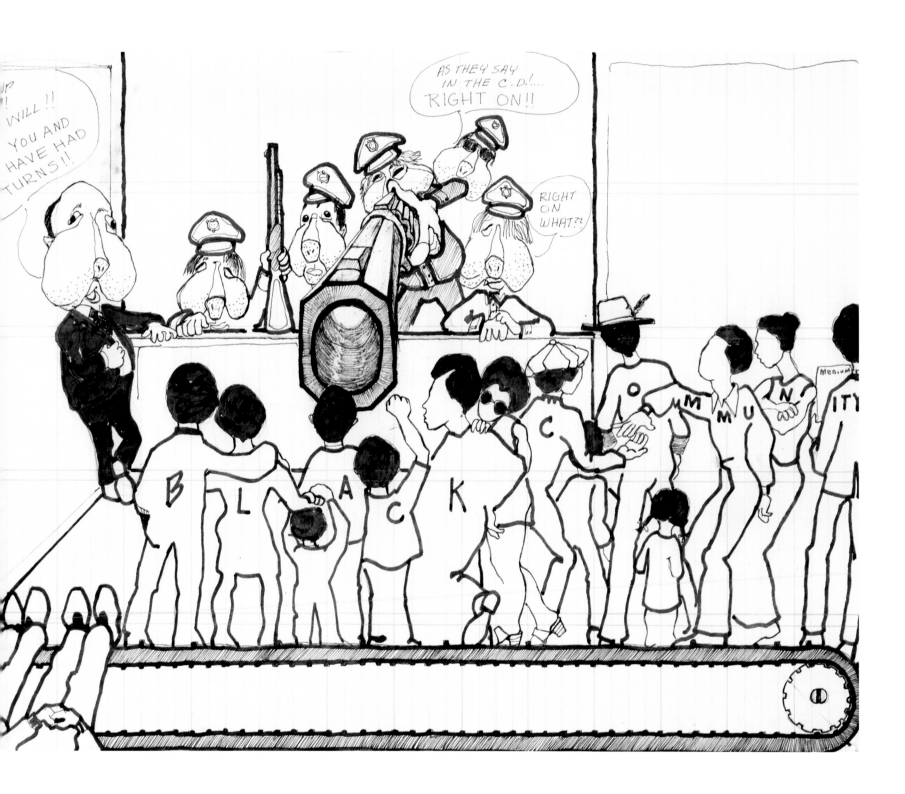

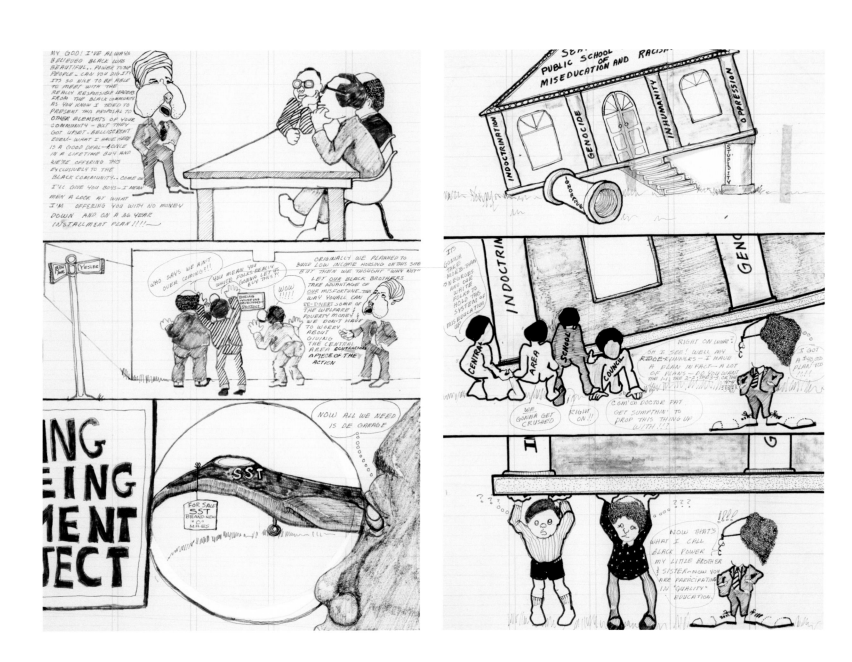

The SST, 1971
Drawing for *Afro American*
Journal 4, no. 17 (April 1, 1971)
Pen and pencil on ledger paper
17 x 11½ in.
Collection of the artist

Seattle Public School System
of Miseducation and Racism, 1971
Drawing for *Afro American*
Journal 4, no. 15 (March 18, 1971)
Pen and pencil on ledger paper
17 x 11½ in.
Collection of the artist

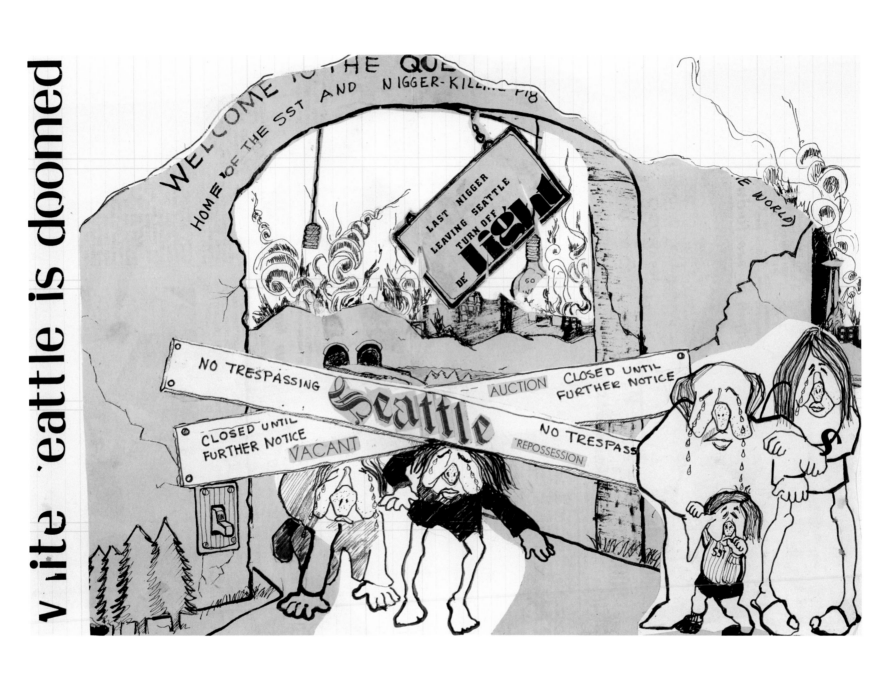

White Seattle Is Doomed, 1971
Drawing for *Afro American
Journal* 4, no. 22 (May 20, 1971)
Mixed media on ledger paper
11½ x 17 in.
Collection of the artist

PAINTINGS 1971–2002

PAINTINGS AND WORKS ON PAPER

Since my return to Seattle in 1971, I have worked in a number of professions to support my family and my art. In August of 2013, after twenty-three years, I retired from a government position. Over that period of time I continued to paint and draw in an effort to continue to grow. I am comfortable with any painting medium. Oil is my first preference, but most of the work is mixed media. When I was younger, I tried to hide evidence of any brushstrokes in my paintings; now my brushstrokes play a different role. A blank canvas is an empty space until you impose your will, and typically you have one empty frame to say what you have to say. I have a head full of paintings, and I know I won't get to paint most of them.

The first thing I decide is the location of the axis of the painting. There is something about the process of deciding on the configuration of a canvas that impacts your ability to do anything with it—plus the process of using a brush. Part of it has to do with being raised in the Western tradition, which reinforces the vanishing point and similar principles even in Abstract Expressionism. I can't speak for anyone else, but for me, during the process, there is a necessity to set myself free from constraints and from proving whatever I was trying to prove to myself by painting on canvas.

I paint primarily people of color—which actually includes everybody, if you think about it—in an attempt to see the range of color. I never have been satisfied with black and brown as the basis of illustrating color. People of color come in a wide range of colors with infinite variations: greens, blues, purple, yellow, orange, and buff. From a color standpoint, I have never seen a black person, or a white person, for that matter. Terms like "black" and "white" have no basis in reality. The range of colors that I use is meant to reflect the intersection of natural and artificial light. I call it "neon."

The hand and foot treatment that has evolved in my work is meant to symbolize that human beings are predatory under the thin layer of civility we project. I have tried to paint peaceful, well-coordinated, contained, nonpolitical paintings and make peaceful drawings, but every time—somewhere in the process—something happens that winds up driving my work in the direction it seems to take.

I wanted to do the same thing in painting that I was doing with line in the *Mask* series of pen and ink drawings. A mask is a face we wear. We have a public mask and a private mask; some we can take off, some we can't. It is the difference between being on camera and off camera.

My conté drawings celebrate the female form, but the majority of my works break down into various overlapping series in terms of content. They include *Television in the Sky*, *Street Life*, *Saturday Afternoon at the Movies*, *A Cowboy Named Bubba*, *Vigilante*, *Mask* (which is an overriding theme throughout my entire work), and *Audio Talisman*.

*Junkie Finds a Broken
Mirror and Looks Forward
into His Past*, 1971
Mixed media on canvas
30 x 31½ in.
Collection of the artist

16

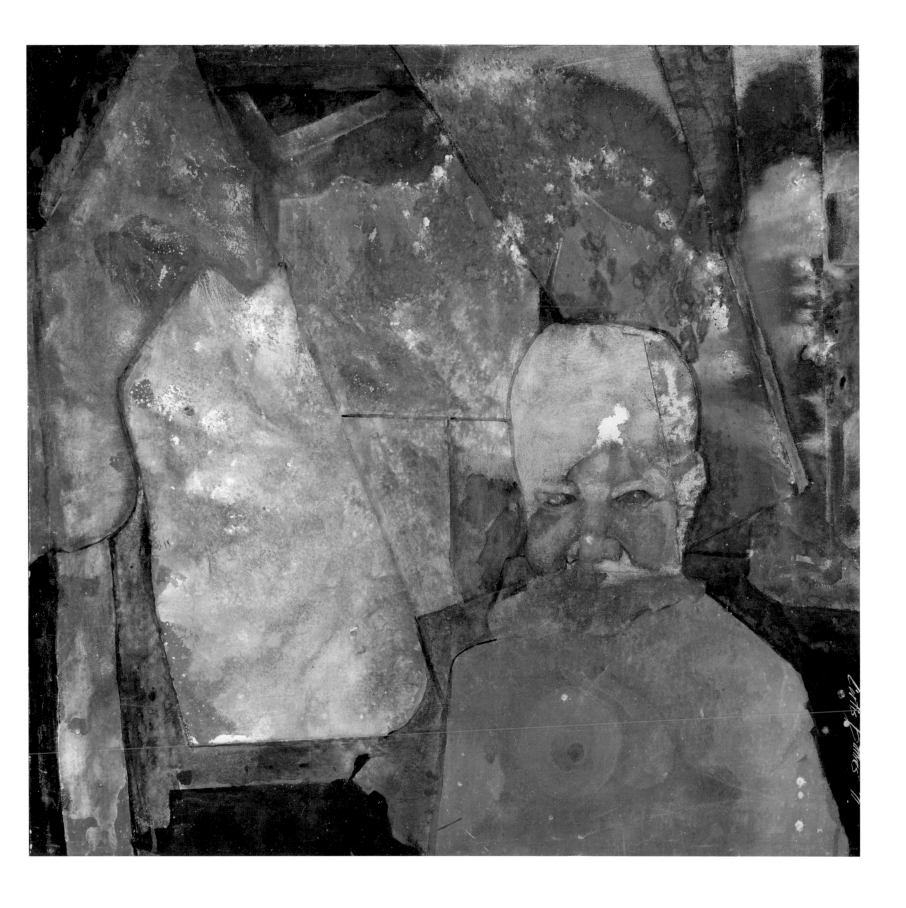

17

The Gift, 1974
Mixed media on canvas
40 x 47 in.
Collection of the artist

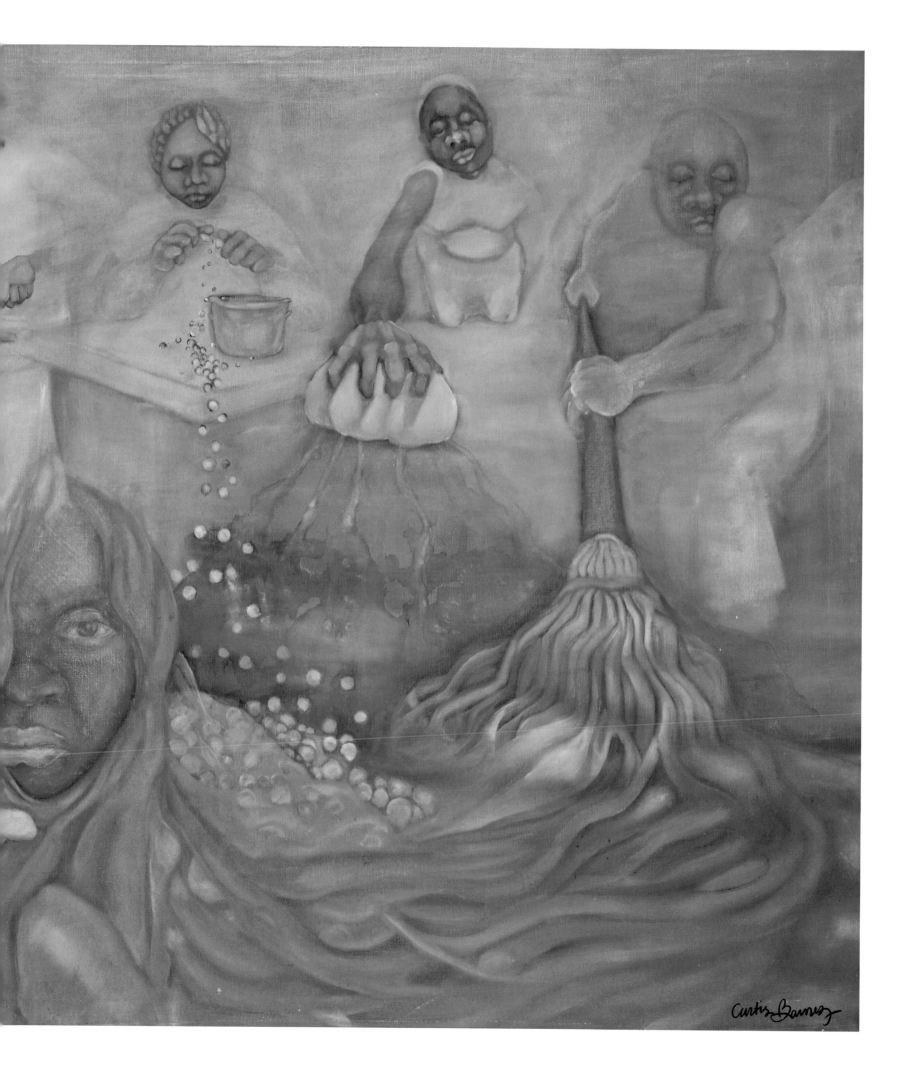

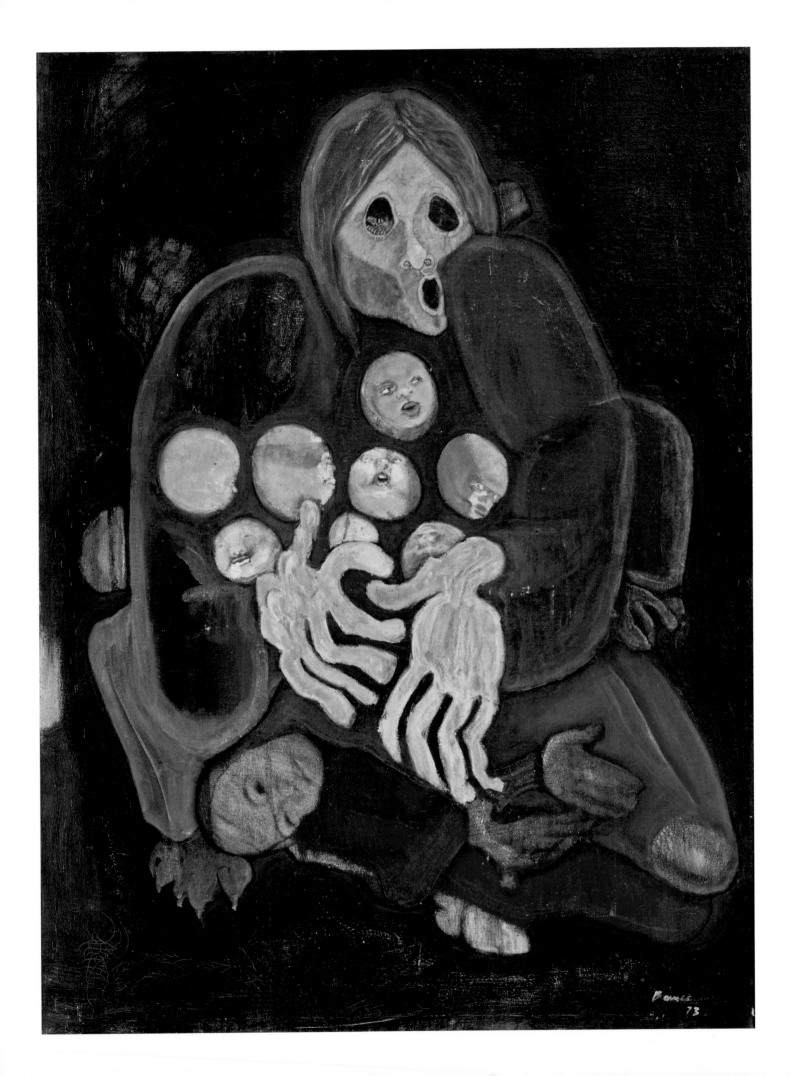

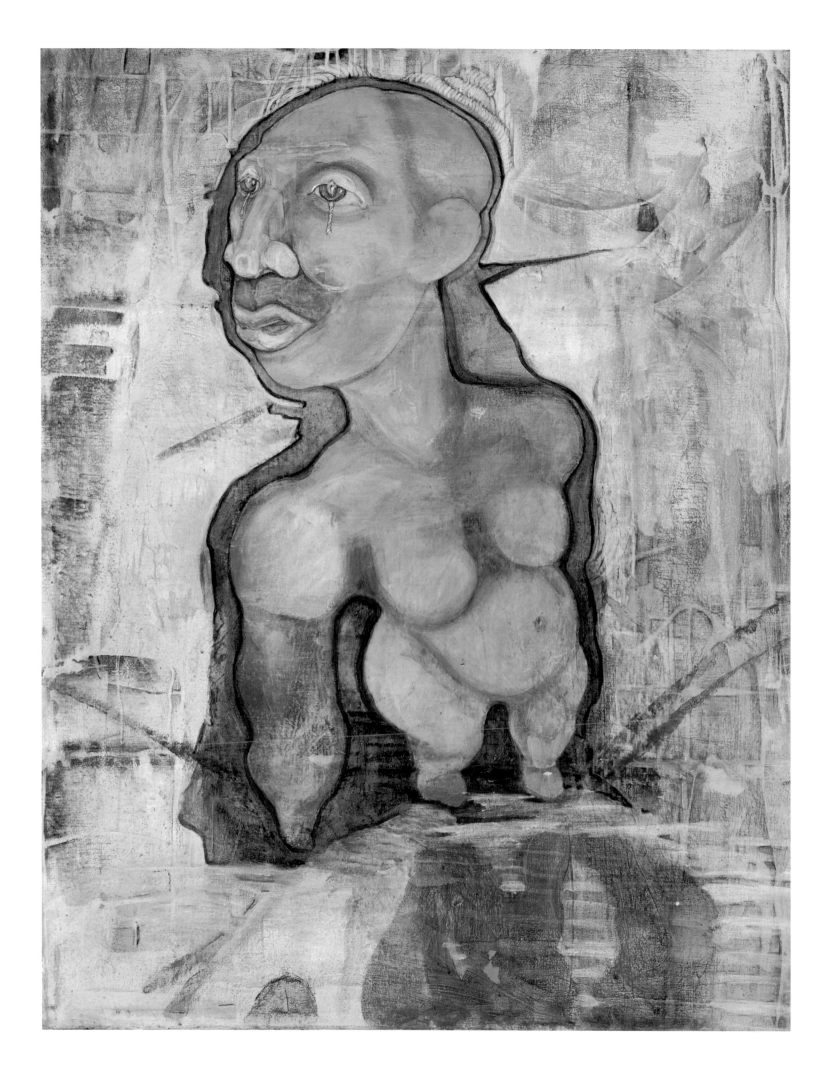

Page 20
A Disciple from the School of
Social Work / Slowly Descending /
Juggling the Future, 1973
Mixed media on canvas
48½ x 35½ in.
Collection of the artist

Page 21
Looking for Open Windows
among the Shadows of the
Cocaine Envelope, 1980
Mixed media on canvas
47 x 37 in.
Collection of the artist

Opposite
Moonlight Escape into the
Badlands, from the *Cowboy*
Named Bubba series, 1988
Mixed media on canvas
24¼ x 24 in.
Collection of the artist

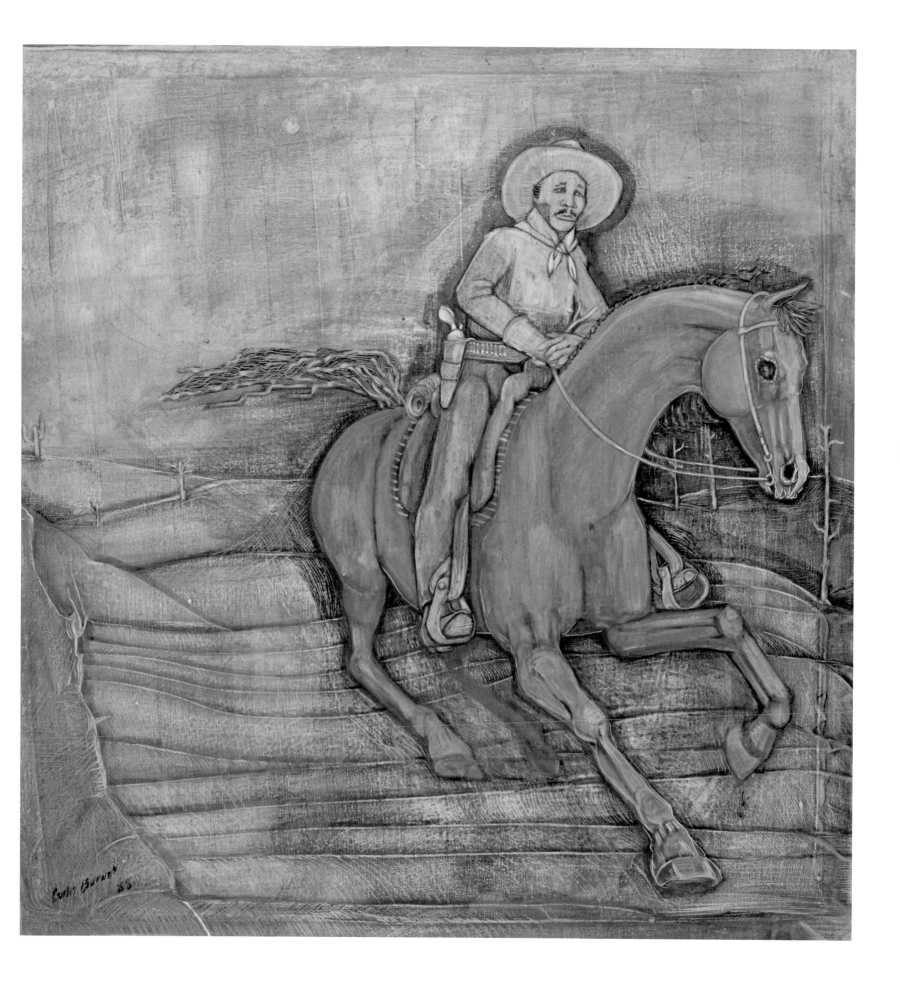

In *Night Riders*, a cowboy named
Bubba is being chased by the Night
Riders, the Ku Klux Klan. He is
resisting. They come to a chasm that
traditionally is known only to Native
Americans. This is an eagle's-eye
perspective of a shoot-out. This
three-quarter, omnipotent eagle's-eye
view draws on perspective in comic
books and their cliff-hanger stories. It
also refers to the serialized nature of
comic-book stories. The figures are
yellow, it is bright, and the moon is up.
The moonlike landscape depicts the
Badlands, a place where only
criminals went. —C. R. B.

Bubba and the Night Riders,
from the *Cowboy Named Bubba*
series, 1995–2000
Mixed media on canvas
24 x 30 in.
Collection of the artist

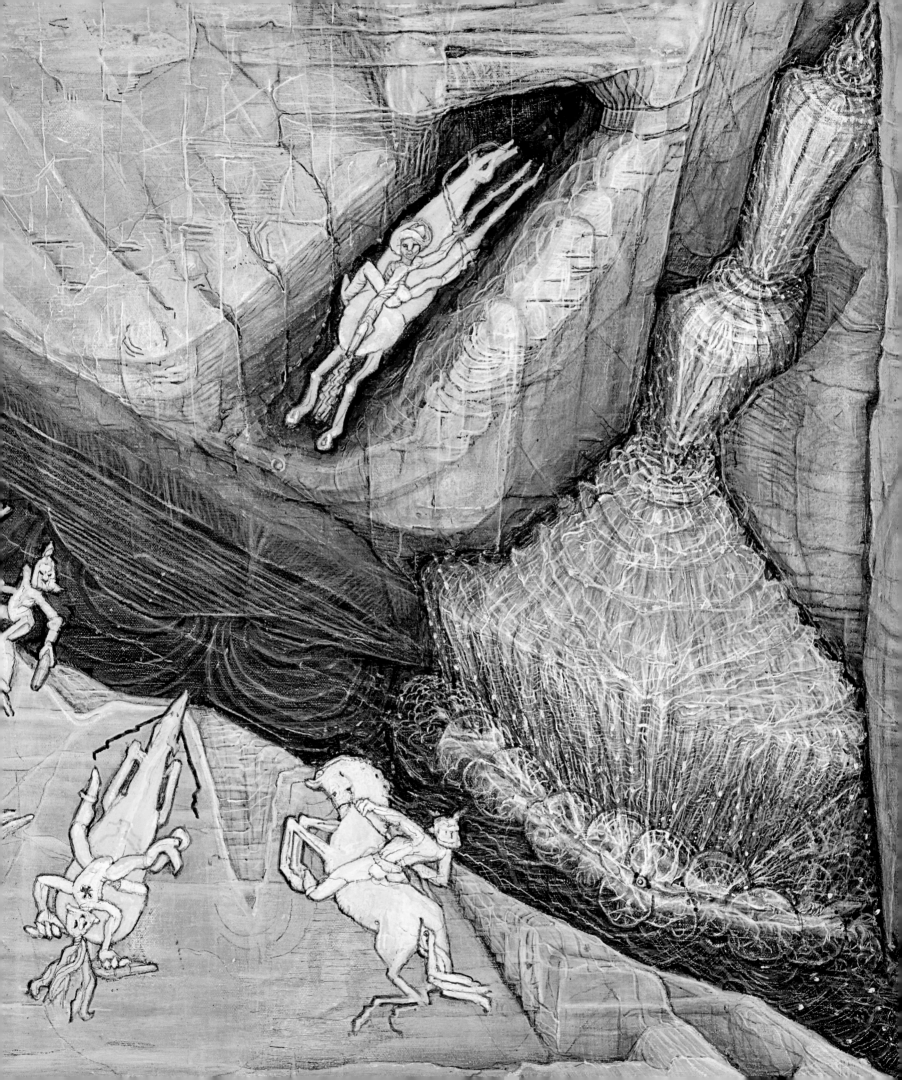

Spirits, 1991
Mixed media on board
22¾ x 19 in.
Collection of the artist 26

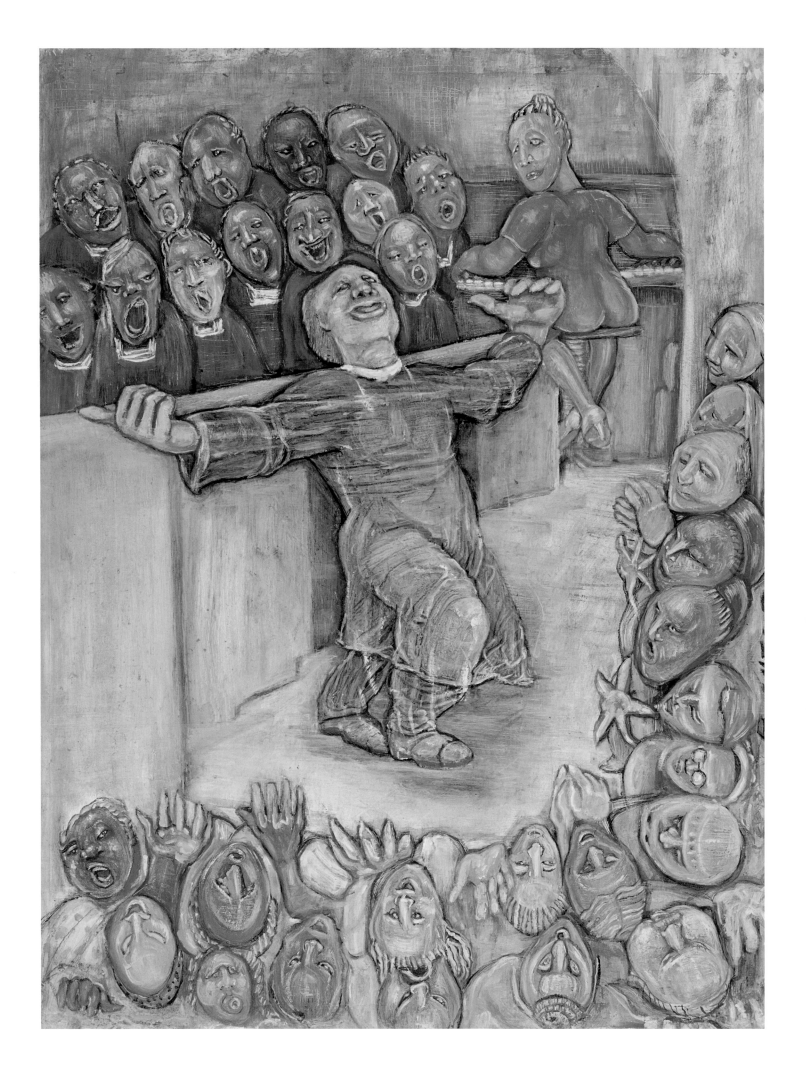

*From a Whisper to a
Scream,* 1999-2000
Mixed media on canvas
39 x 29 in.
Collection of the artist 28

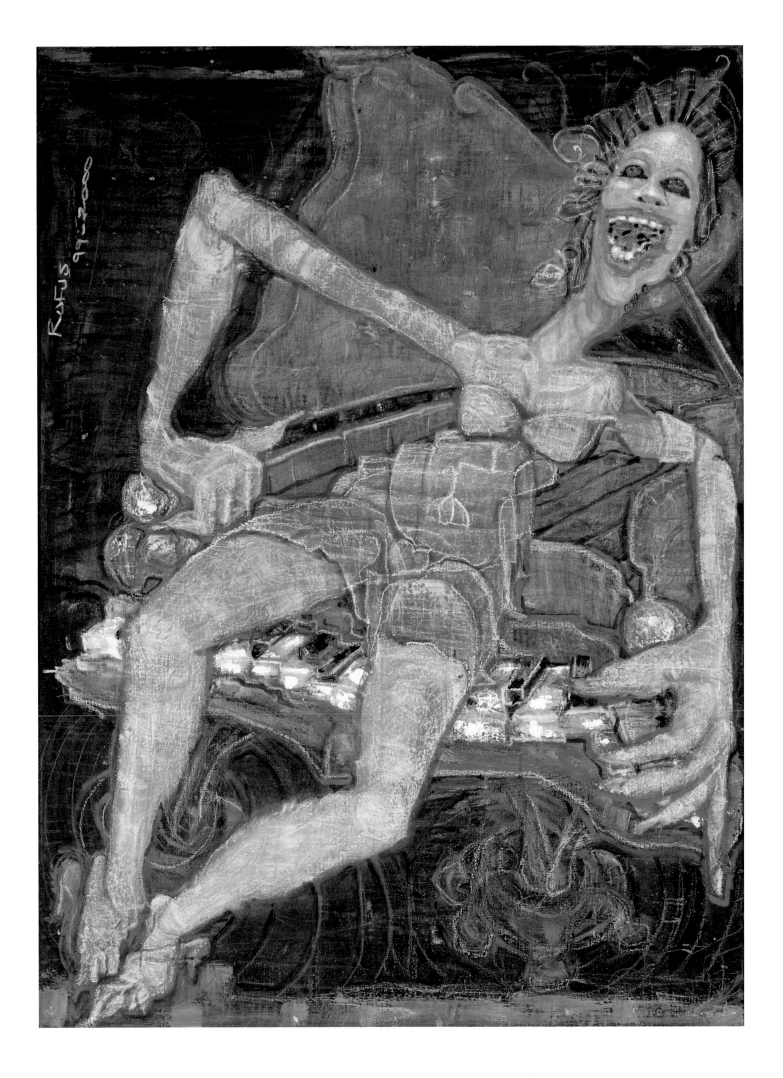

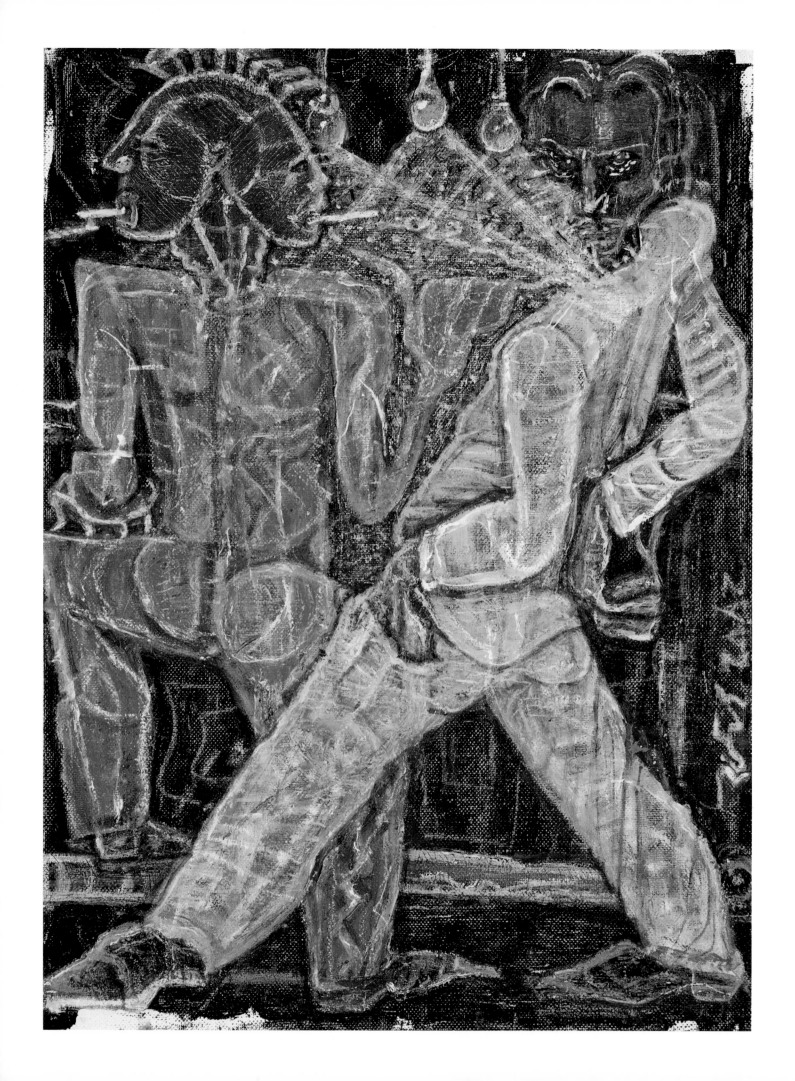

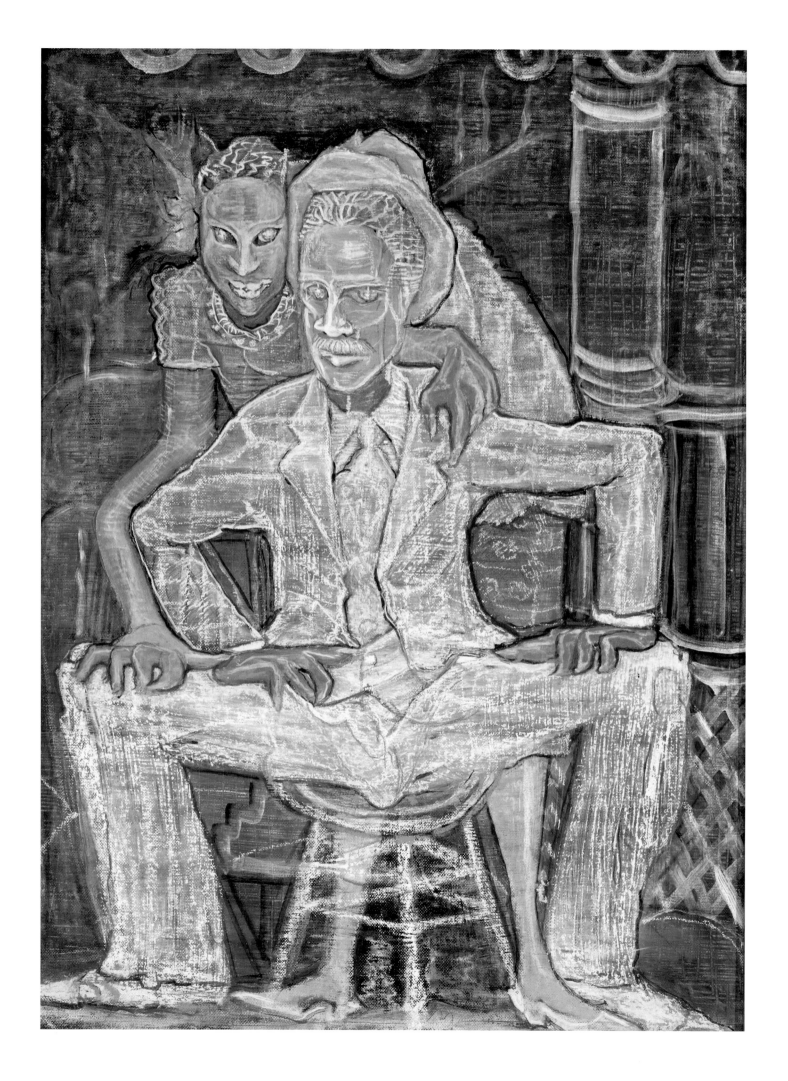

Page 30
Last Dance / Lights Out, 2002
Mixed media on board
16 x 12 in.
Collection of the artist

Page 31
*Bebe's Kids' Grandparents
Down on the Farm*, late 1990s
Mixed media on canvas
24 x 18 in.
Collection of the artist

Opposite
*Hater Sitting on a Fence
Watching You Walk By*, 2000
Mixed media on canvas
19¾ x 16 in.
Collection of the artist

THE FEMALE FORM

I try to celebrate and comment about the female form in all its subtleties. The conté series began after my ten-year high school reunion. It was my reaction to watching beautiful women in a variety of shades who had grown ten years older. It's about illustrating aging and the passage of time.

It was profound to me then, and now that I'm the age I am, I recognize that these paintings are about time, the weight of time. It is about starting out with goals when we're young and asking whether we achieved them, and, if we did, what do they mean? It's about aging and celebration at the same time.

The representation of women in these works is also about the classical female-male relationship that can be flawed. I have friends who seem to have an innate understanding of women, but I'm not one of them. I'm mystified, but I'm happy being mystified. I have the utmost respect for women. That's probably the only way that my relationship with the woman I live with has been able to survive.

There's a dynamic between men that needs to be explored. There's a dynamic between men of color that they need to look at, forms and levels of communication between us, which are still very primitive in terms of what's possible.

On the Other Side of That Time
of the Month, 1976
Pencil and conté on paper
14 x 9½ in.
Collection of the artist

34

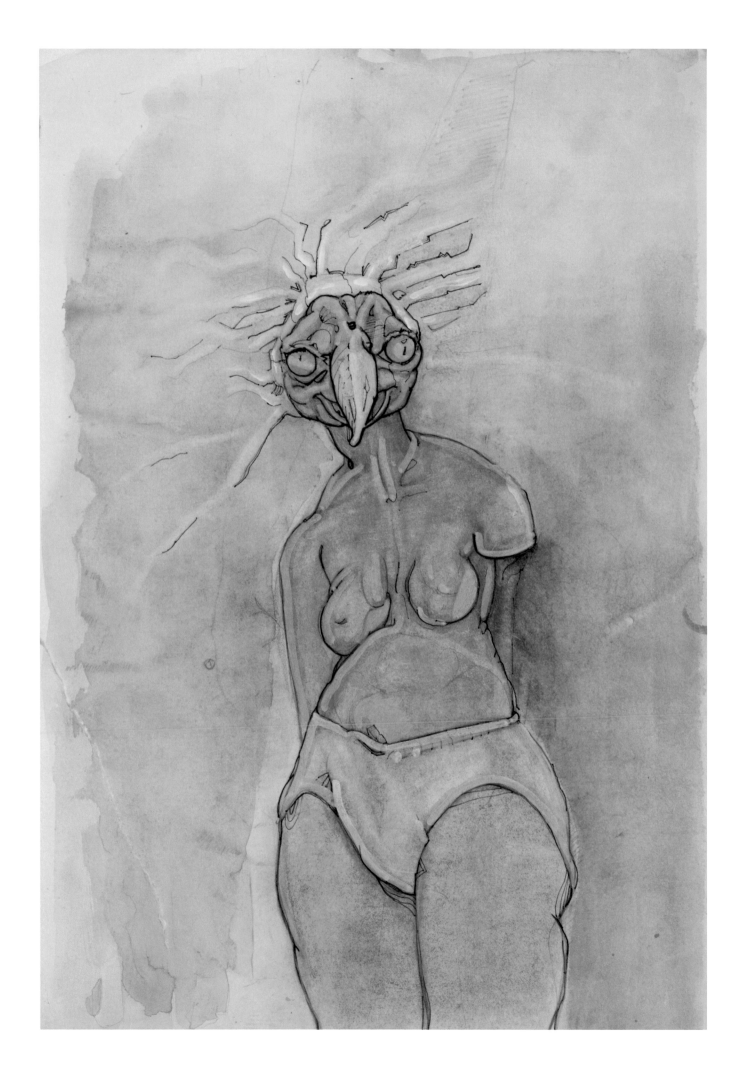

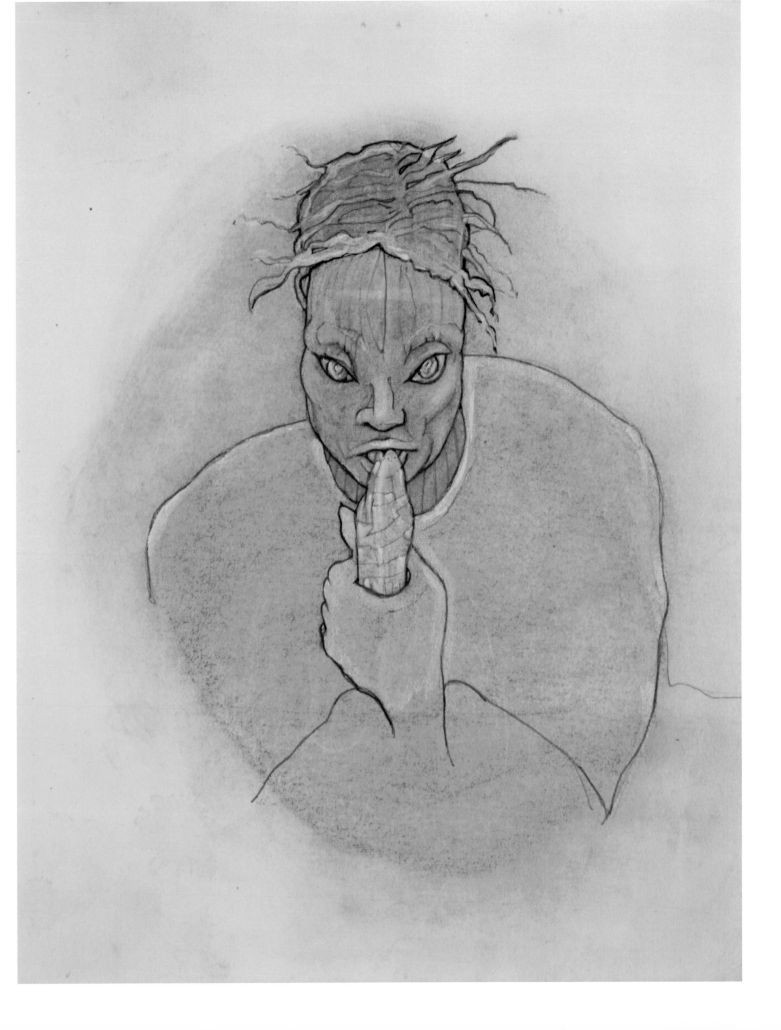

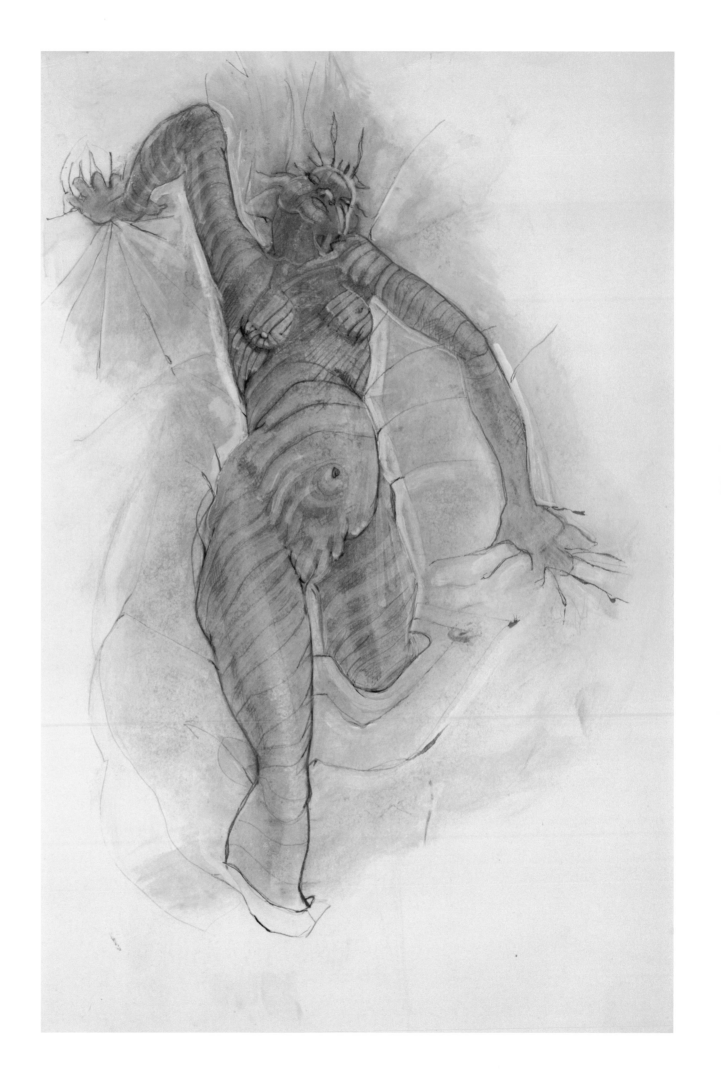

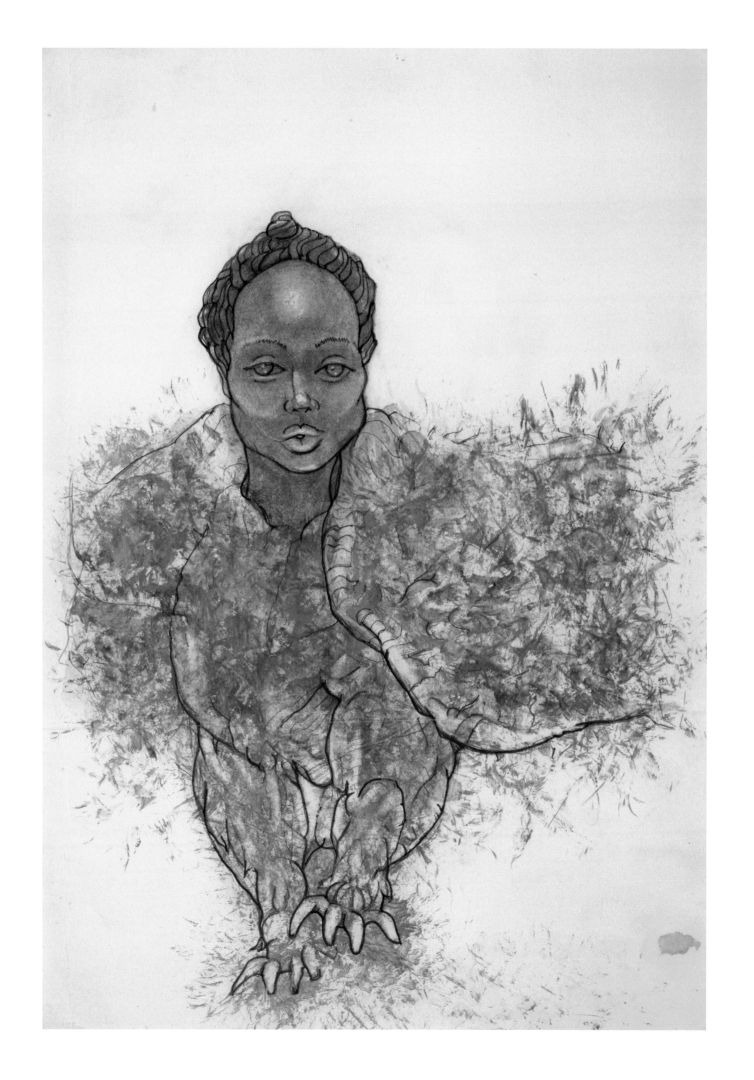

This series of drawings is about homelessness and a different political time. It represents a series of statements about the results of trickle-down economics and the impact of not maintaining a safety net.
—C. R. B.

Clockwise from top left

Untitled, from the *Street Life* series, n.d.
Pen, ink, and marker on paper
11 x 8½ in.
Collection of the artist

Untitled, from the *Street Life* series, n.d.
Pen and ink on paper
11 x 8½ in.
Collection of the artist

Untitled, from the *Street Life* series, n.d.
Pen, ink, and black marker on paper
11 x 8½ in.
Collection of the artist

Queen of the May Day Parade / Class of '62 / Clark Kent High, from the *Street Life* series, n.d.
Pen and ink on paper
11 x 8½ in.
Collection of the artist

Opposite
Cornered Fox, from the *Street Life* series, n.d.
Pen, ink, and conté on paper
11 x 8½ in.
Collection of the artist

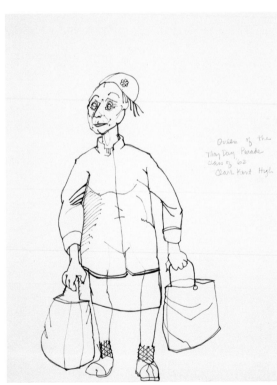 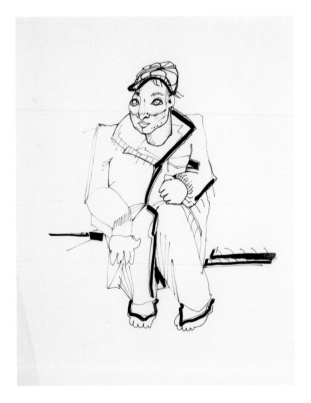

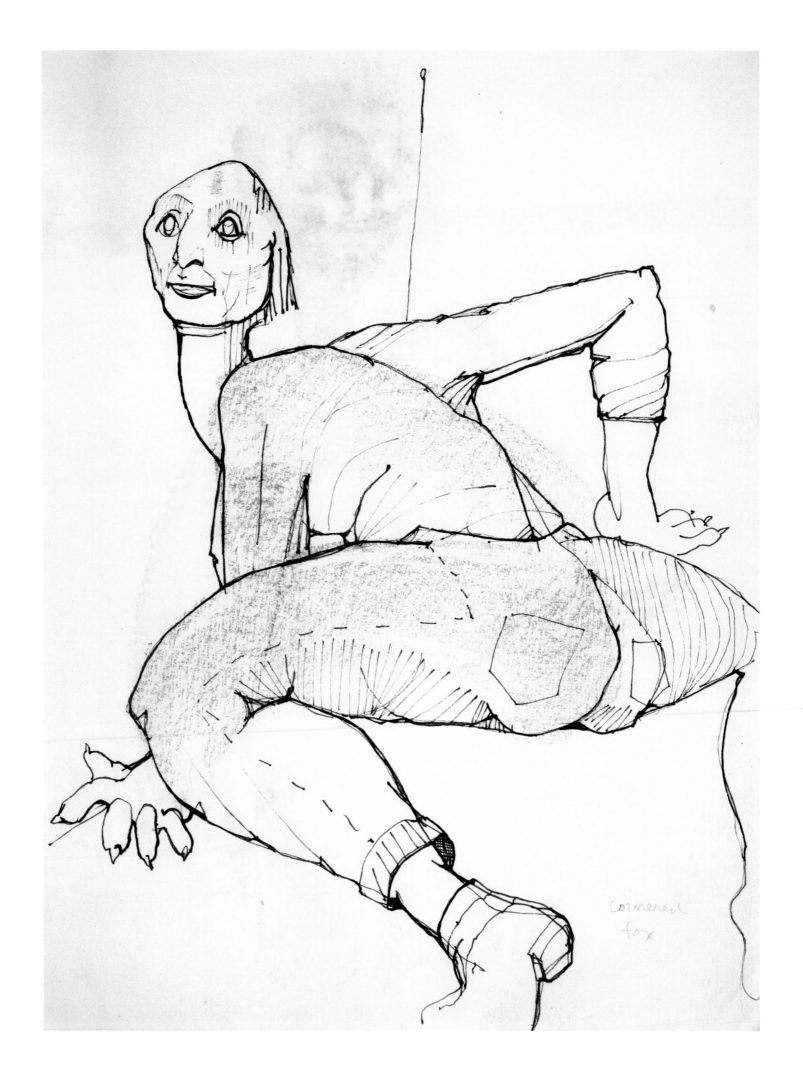

cornered
fox

THE *MASK* SERIES

This series arose from wide-ranging pen and ink drawings that started in the mid-'70s and continue to this day. It is based on the theory that we all wear a variety of masks, public and private, and covers a wide range of subjects including apartheid, urban gargoyles, musicians, and personalities.

The idea of masks and the *Mask* series refer to a deeper issue than the cartoons. The drawings were a means to assess human nature and the layers that we construct for ourselves. They were also technical exercises based on my study of Islamic art and architecture and ancient mysticism, and reflected how long I could keep pen to paper without stopping.

In one of my early *Mask* works, I refer to the policy of apartheid and the situation in South Africa at a particular point in time (see p. 5). But there's also an economic apartheid, which is practiced here in America on a masterful level. There's spiritual apartheid. By that, I mean the destruction of a person's ability to dream, of how they see their own potential. Yes, there is the responsibility for *allowing* someone to destroy your dream. But when we talk about institutionalized racism here in America, it's on automatic pilot. There's no lever; you don't have to activate it; it is already operational.

The issue becomes—how do you get what you're after without destroying yourself? How do you take responsibility for continuing to resist to the degree of your understanding? How do you remain intact in an ongoing day-to-day reality? That's not only a reality for people of color; it's a reality for everybody because it's not hard to get ground up, or to get in the way. So the issue is: How do you stay out of the way? And if the tightrope that you're on is a razor blade, then how do you deal with that and remain halfway sane?

There are figures in society, independent of race, who are capable of either giving hope or destroying hope. One of them, for example, is the loan officer. In the more recent past, we have seen the devastation of people's lives through loan officers who assume an importance in your life in terms of what size your loan is going to be and what you can do in this capitalistic society. A banker friend of mine told me one day, "You know, we take all this information and calculate profit and loss, but really it's based on what we think your character is." A loan officer is a gatekeeper who decides whether or not they're going to let you in. My *Loan Officer* is a composite of some I've had the pleasure of talking to.

So Happy to Meet You / Used Car Salesman, from the *Mask* series, n.d.
Pen and ink on paper
8½ x 10½ in.
Collection of the artist

Chas Darwin III, from the *Mask* series, 1982
Pen, ink, and opaque correction fluid on paper, mounted on graph paper
8½ x 10½ in.
Collection of the artist

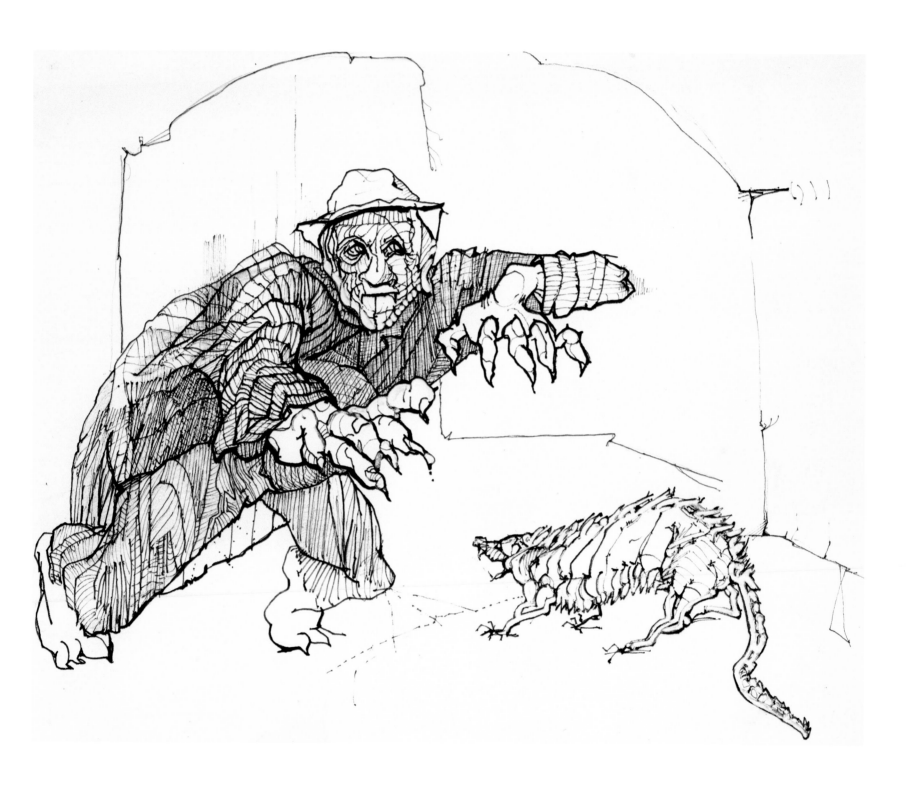

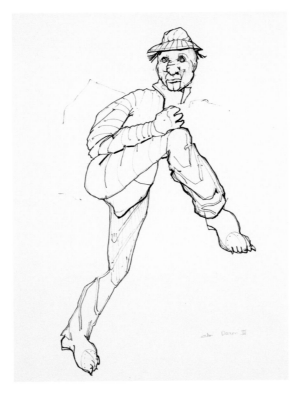

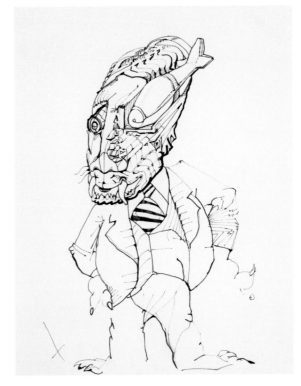

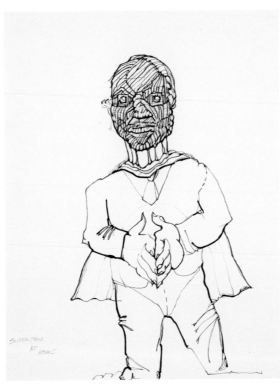

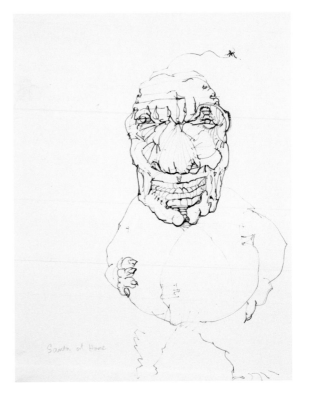

Clockwise from top left

Chas Darwin III, from
the *Mask* series, n.d.
Pen, ink, and opaque
correction fluid on paper
10 x 8½ in.
Collection of the artist

Apartheid, from the
Mask series, 1984
Pen, ink, and opaque
correction fluid on paper,
mounted on graph paper
12½ x 8½ in.
Collection of the artist

Santa at Home, from
the *Mask* series, n.d.
Pen, ink, and opaque
correction fluid on paper
10½ x 8½ in.
Collection of the artist

Superman at Home, from
the *Mask* series, n.d.
Pen, ink, and opaque
correction fluid on paper
10½ x 8½ in.
Collection of the artist

Opposite
*Florence Nightingale
Watching General Hospital,*
from the *Mask* series, 1984
Pen, ink, and opaque
correction fluid on paper,
mounted on graph paper
12½ x 8½ in.
Collection of the artist

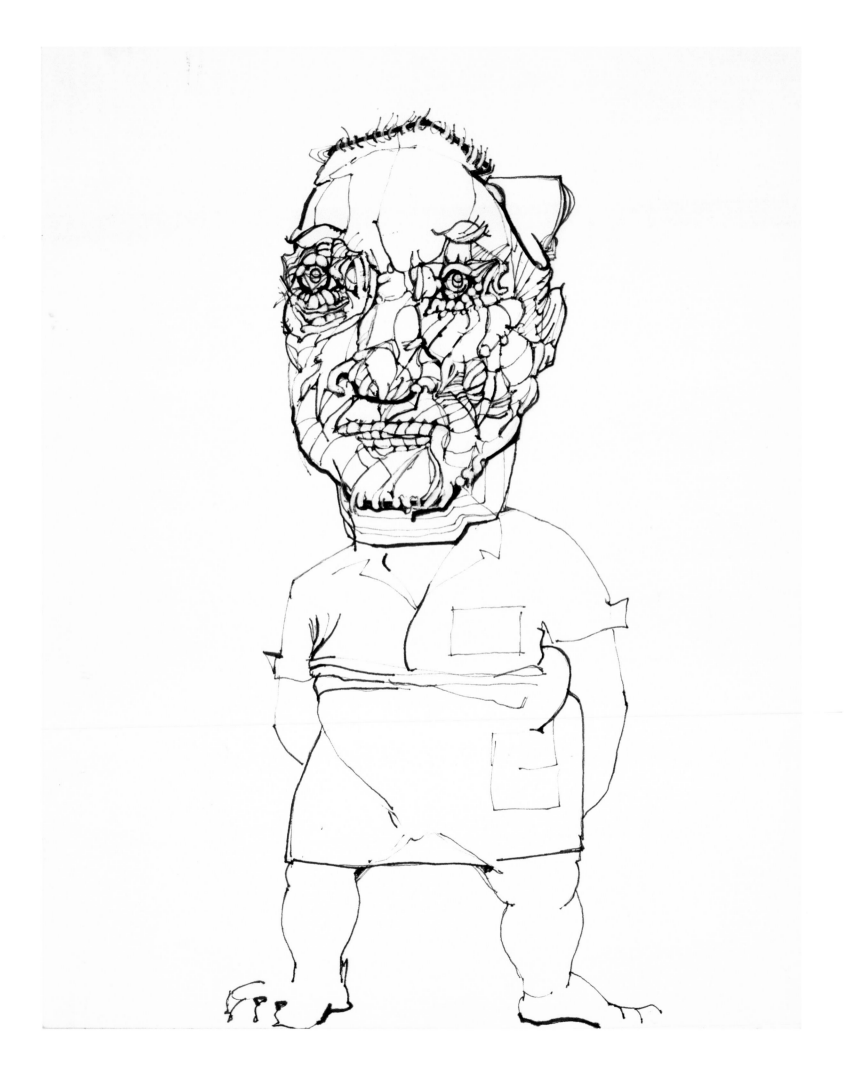

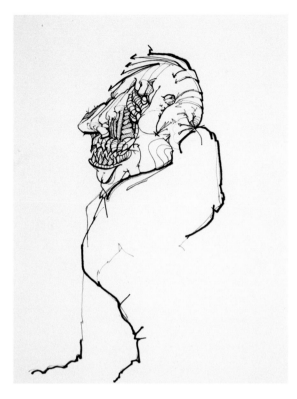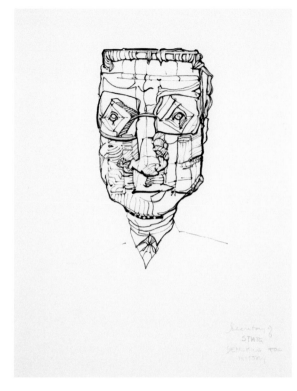

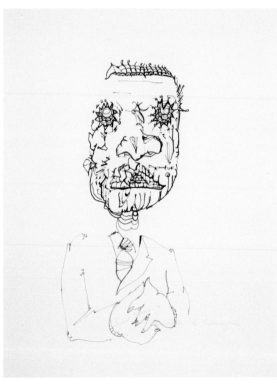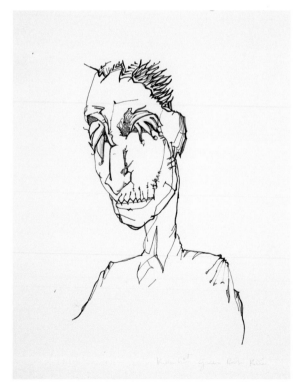

Clockwise from top left

Payoffs and Kickbacks, from
the *Mask* series, 1983
Pen and ink on paper,
mounted on graph paper
12½ x 8½ in.
Collection of the artist

*Secretary of State Searching
for History,* from the *Mask*
series, n.d.
Pen, ink, and opaque
correction fluid on paper
10½ x 8⅜ in.
Collection of the artist

Green River Killer, from the
Mask series, n.d.
Pen, ink, and opaque
correction fluid on paper
10½ x 8½ in.
Collection of the artist

Child Molester, from the
Mask series, n.d.
Pen and ink on paper
10½ x 8½ in.
Collection of the artist

Opposite
Defense Contractor, from the
Mask series, 1984
Pen, ink, and opaque
correction fluid on paper,
mounted on graph paper
12½ x 8½ in.
Collection of the artist

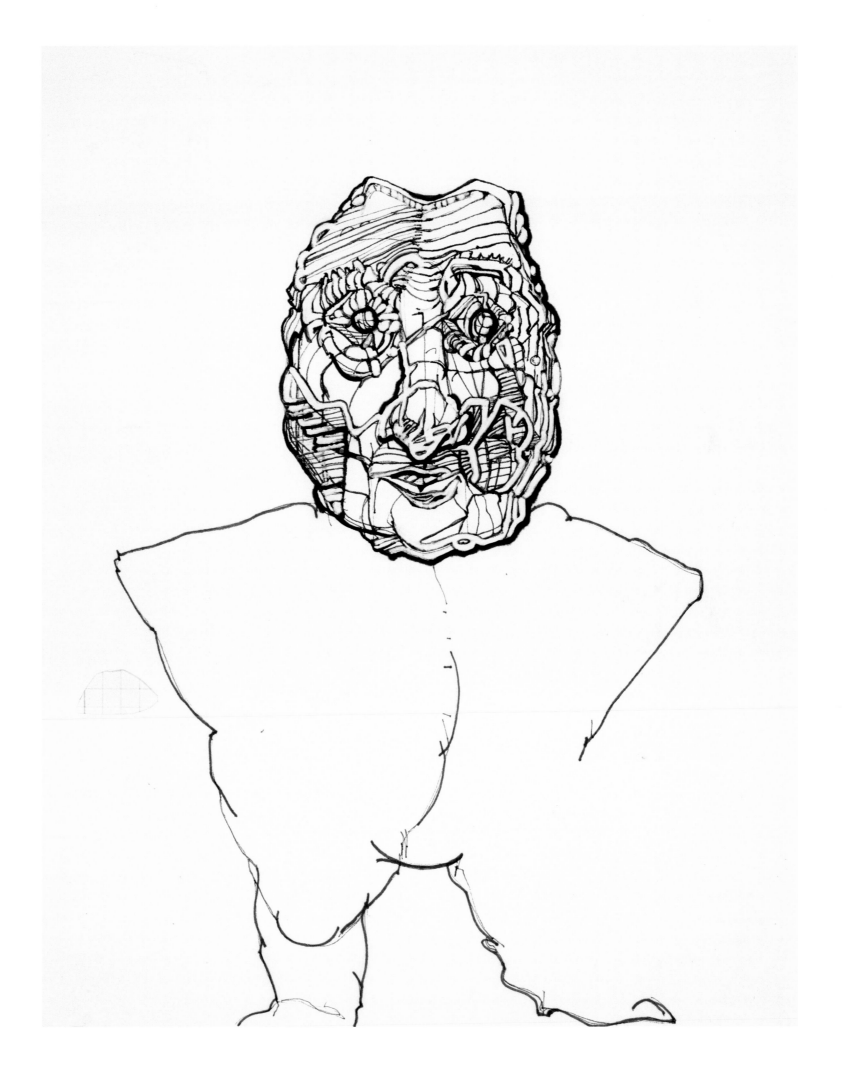

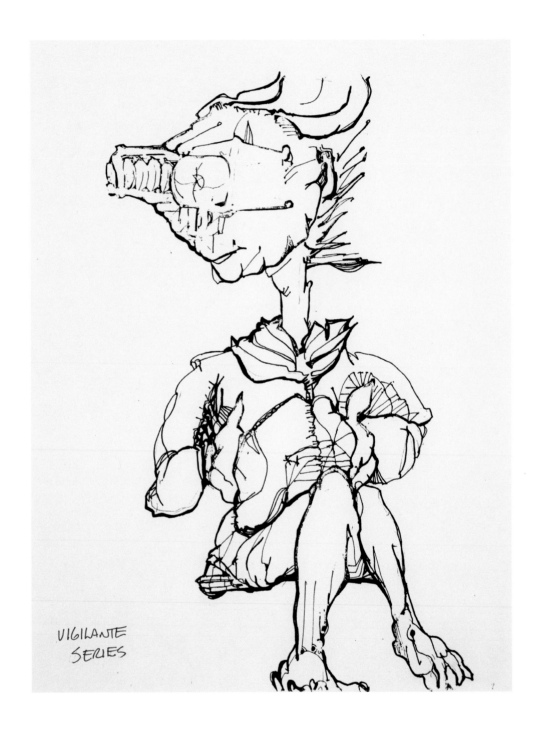

Bernhard Goetz was on the subway in 1984 armed with a weapon and shot four African American teenagers. He assumed hero status almost instantly. The *Vigilante* series began with this work about Goetz, but it is also about the killing of Trayvon Martin by George Zimmerman in 2012 and Florida's "stand your ground" law. It's about people taking away a life; it is about the duty to retreat. —C. R. B.

Untitled, from the
Vigilante series, n.d.
Photocopy of original drawing
11 x 8½ in.
Collection of the artist

Untitled, from the
Vigilante series, n.d.
Photocopy of original drawing
11 x 8½ in.
Collection of the artist

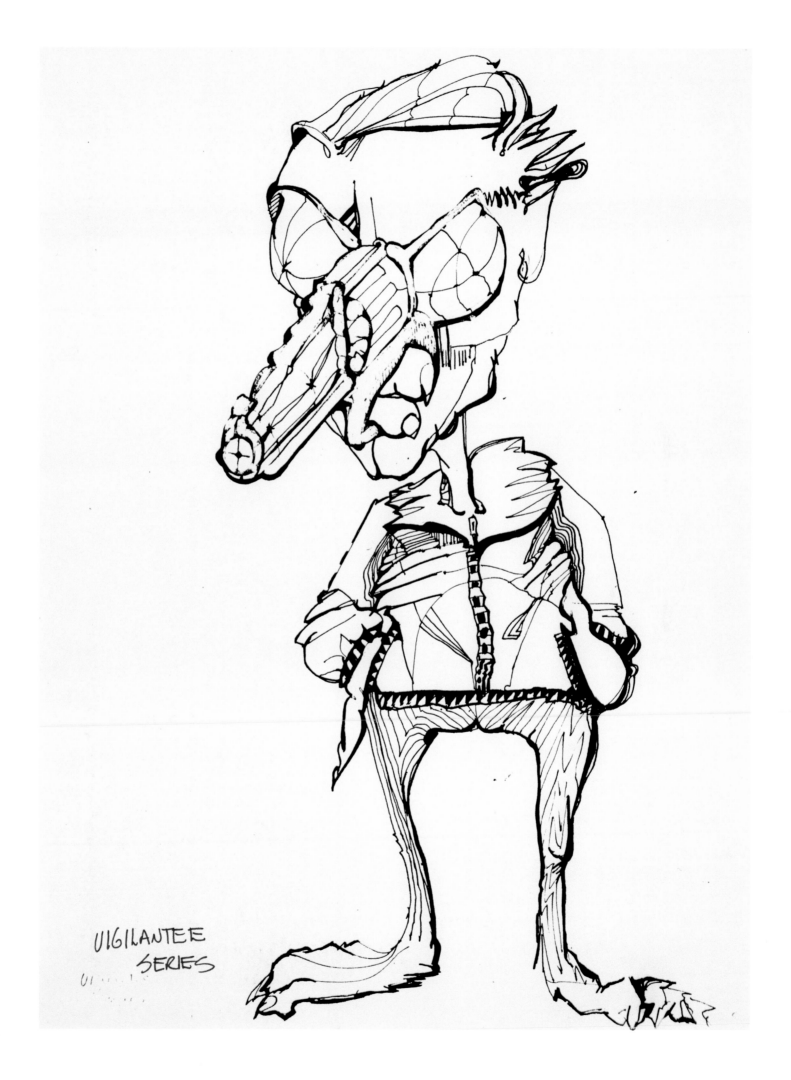

VIGILANTEE
SERIES

THE SILVER SCREEN

The *Saturday Afternoon at the Movies* series of pen and ink drawings is about constructing fictions, celluloid realities. It is also an acknowledgment of the impact that the silver screen had on me. One of the things that struck me about writers like William Faulkner is that they construct an entire environment to illustrate a certain point of view. The musician-philosopher Les McCann has a line in one of his songs—"tryin' to make it real compared to what"—and that's the question I ask myself: "Compared to what?"[6]

The icons and heroes depicted in the movies have clay feet, too. The decidedly fictional, celluloid gangsters, cowboys, heroes, and heroines have a way of becoming real. They also tend to be white and have guns. I consider *Saturday Afternoon at the Movies* to be part of the *Mask* series.

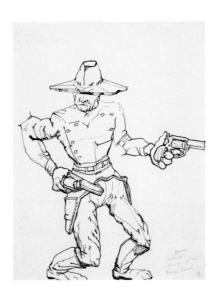 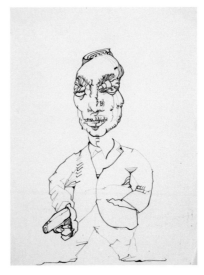 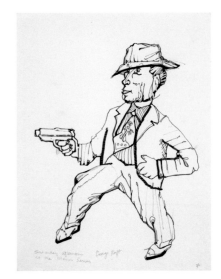

Hero, from the *Saturday Afternoon at the Movies* series, n.d.
Pen, ink, and opaque correction fluid on paper
11 x 8½ in.
Collection of the artist

Sydney Greenstreet, from the *Saturday Afternoon at the Movies* series, n.d.
Pen, ink, and opaque correction fluid on paper
12 x 8⅞ in.
Collection of the artist

George Raft, from the *Saturday Afternoon at the Movies* series, n.d.
Pen, ink, and opaque correction fluid on paper
11 x 8½ in.
Collection of the artist

Do Not Forget Me Oh My Darling, from the *Saturday Afternoon at the Movies* series, n.d.
Pen, ink, and opaque correction fluid on paper
11 x 8½ in.
Collection of the artist

50

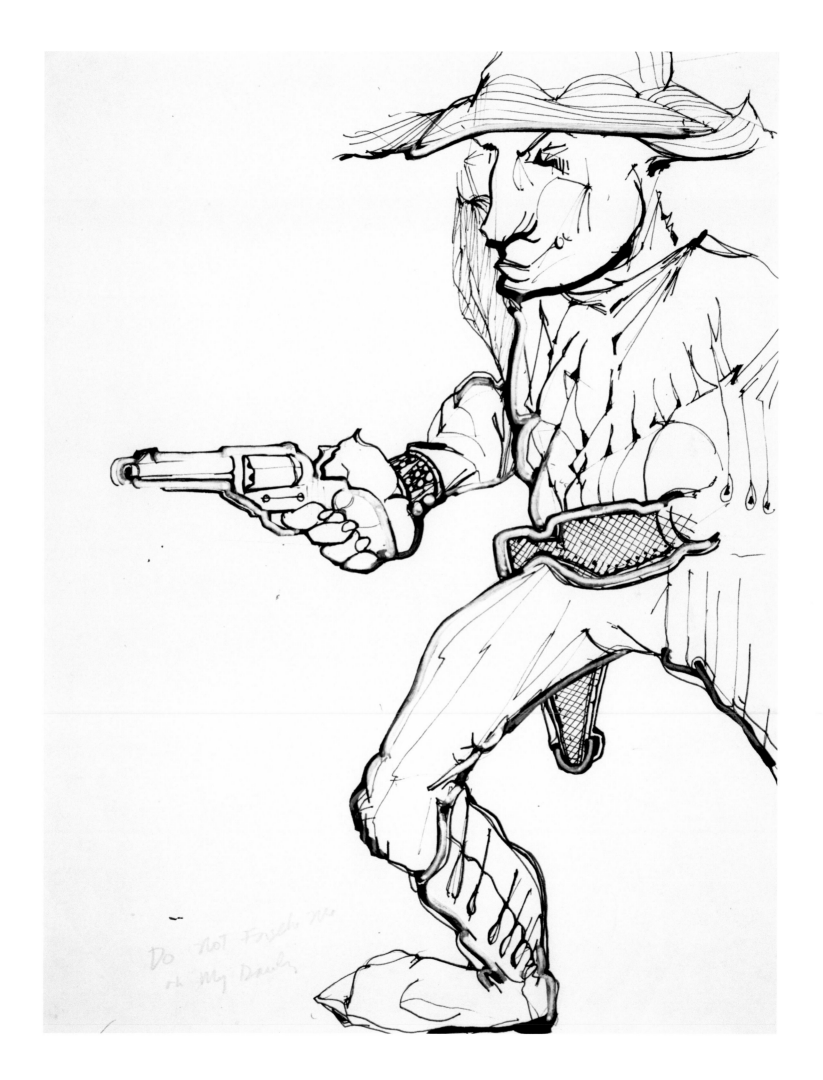

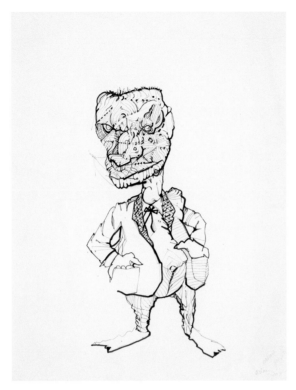

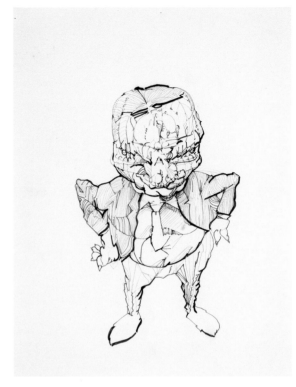

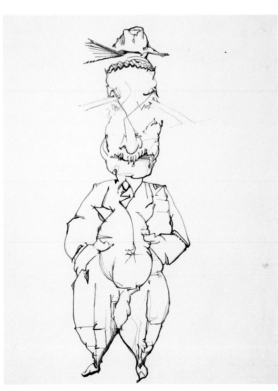

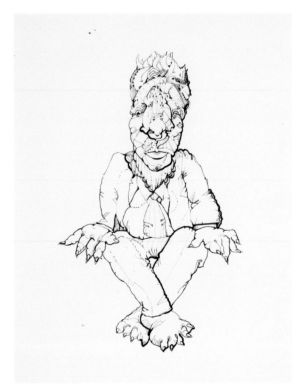

Clockwise from top left

Untitled, from the
Urban Gargoyle series, n.d.
Pen and ink on paper
17 x 14 in.
Collection of the artist

Untitled, from the
Urban Gargoyle series, n.d.
Pen and ink on paper
17 x 14 in.
Collection of the artist

Untitled, from the
Urban Gargoyle series, n.d.
Pen and ink on paper
17 x 14 in.
Collection of the artist

Untitled, from the
Urban Gargoyle series, n.d.
Pen and ink on paper
17 x 14 in.
Collection of the artist

Opposite
Untitled, from the
Urban Gargoyle series, n.d.
Pen and ink on paper
17 x 14 in.
Collection of the artist

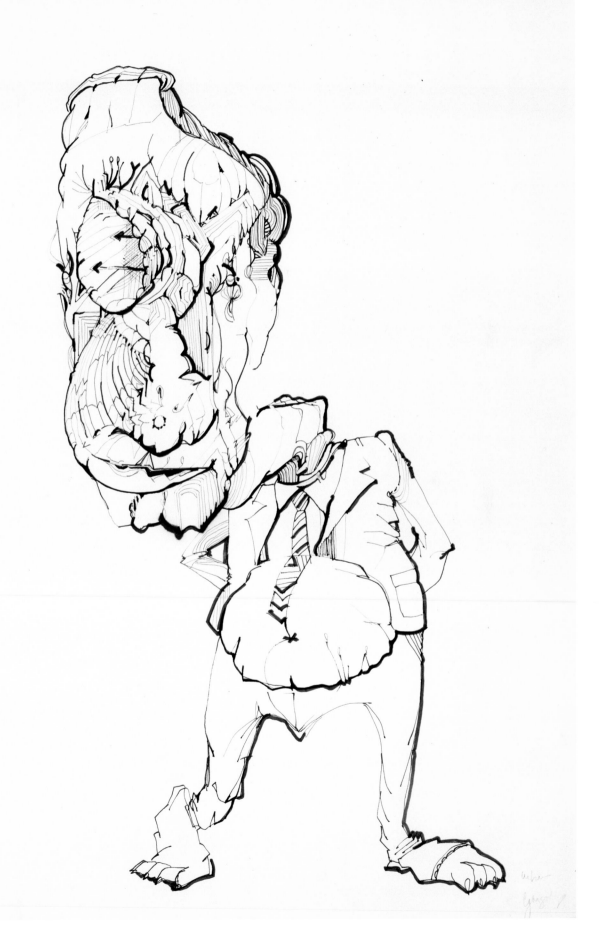

TELEVISION IN THE SKY AND AFRICAN UNICORNS

Television in the Sky represents the imagination, which is limitless. For me, it is a construct that includes unicorns and a place called the Emerald Empire.

Unicorns come from different regions. The classical unicorn that most of us are familiar with has wings and flies. I tend to think of my unicorn as African in origin, no wings but it also flies and has special powers. I also use it as a metaphor for men of color, and it represents the ongoing dynamic tension between men and women.

Incorporating the unicorn was a way of taking possession, of discovering and occupying your own little country—one in which the primary requisite interaction occurs on a civilized basis.

In this country, in my own country, the land is alive, family and ancient traditions are present, and it is possible to live with some actionable measure of integrity. All the ancient, wise peoples of our world have sophisticated interactions and a connection to something elemental. They're definitely tuned in to television in the sky. I don't pretend to understand it, but I do know that it's there, and I have the utmost respect for it.

Taming of the Unicorn, from the
Television in the Sky series, 1998
Mixed media on board
24 x 18 in.
Collection of the artist

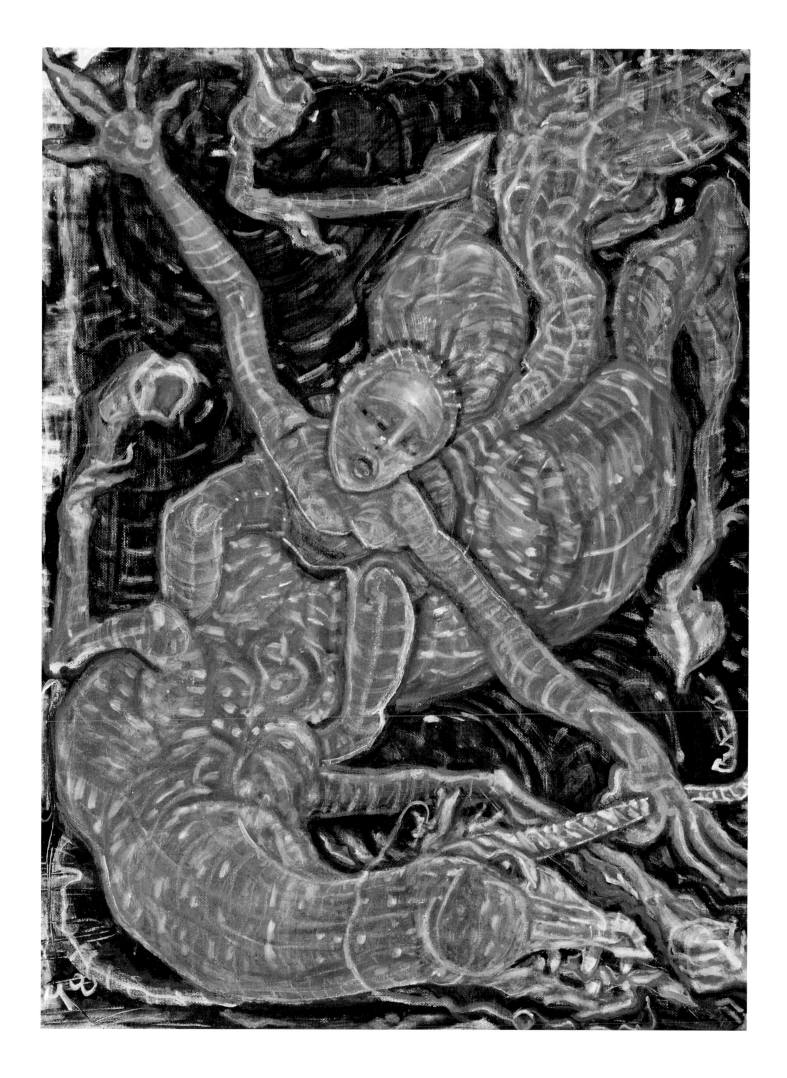

AUDIO TALISMAN / MUSICAL FIGURES / ICONS

As a child, in my youth, and today, I am equally interested in the use of the human voice. My mother always had either the record player or the radio on. And when television came along, she listened to entertainers like Tennessee Ernie Ford. There was no radio station that played music by African American performers, so she listened to a country-western station that played country and the popular standards. I grew up listening to everything. So-called more serious symphonic music, however, wasn't a part of my acoustical diet. I always preferred singers whom I consider to be great vocalists, instruments, and storytellers such as Billie Holiday, Sarah Vaughan, Peggy Lee, Patsy Cline, Dakota Staton, and, lately, Amy Winehouse. I'm happy listening to Sonny Stitt, or listening to Charlie Parker, John Coltrane, or Sonny Rollins. There is a form of telepathy and interaction in jazz—with any two or more people involved in something acoustical. What I try to capture is that interaction that goes beyond the instrument. Each musician has his or her own signature, a way they hit and hold those notes.

The *Audio Talisman* series is my way of paying homage and respect to the many musicians who have blessed us with their creativity and protection. I try to say in my work that the various instruments depicted come to life and change form when played by a master. I can't say enough about the positive interaction of telepathy and magic that musicians create.

You can't insert negativity into a performance; the dissonance that takes place is positive. Jazz transcends labels; it is an intimate form of interaction. I try to incorporate music as much into my work as any other sensation. Improvisation is part of the magic, and, hopefully, that's what's taking place for me. Probably the most difficult thing for me has been learning and maintaining some level of discipline. Improvisation, on the other hand, does encourage a certain frame of mind. There's a flow that takes place between your hand and your mind; something that you have no control over whatever appears in spite of yourself and your ego, especially in my pen and ink drawings.

Big Mama Thornton Letting the Hound Dog Loose, 1987
Mixed media on canvas
17¾ x 13¾ in.
Collection of the artist

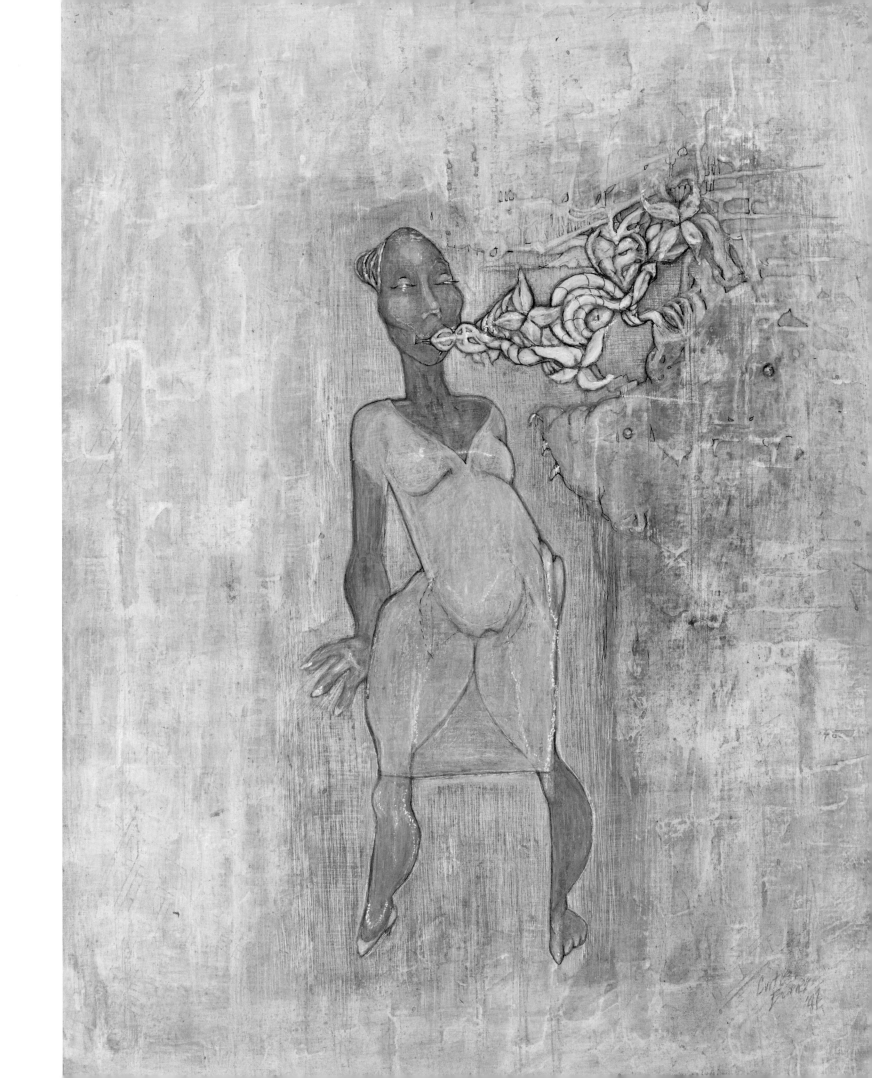

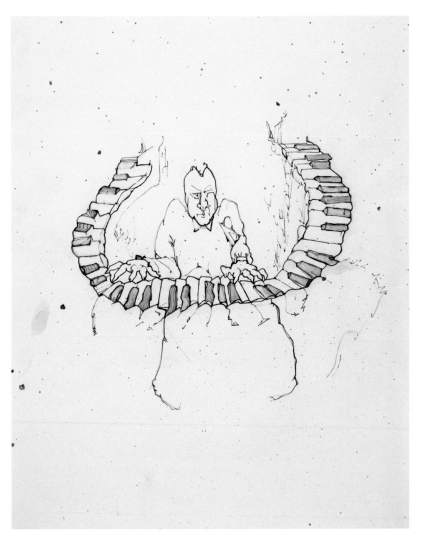

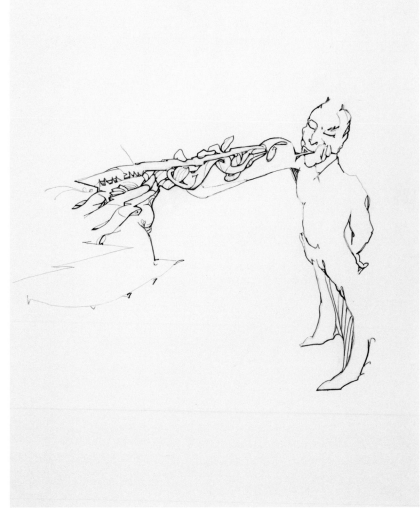

Thelonious Monk, from the
Audio Talisman series, n.d.
Pen, pencil, and opaque
correction fluid on paper
17 x 14 in.
Collection of the artist

Lee Morgan, from the
Audio Talisman series, n.d.
Pen, pencil, and opaque
correction fluid on paper
17 x 14 in.
Collection of the artist

Art Tatum, from the
Audio Talisman series, n.d.
Pen, pencil, and opaque
correction fluid on paper
17 x 14 in.
Collection of the artist

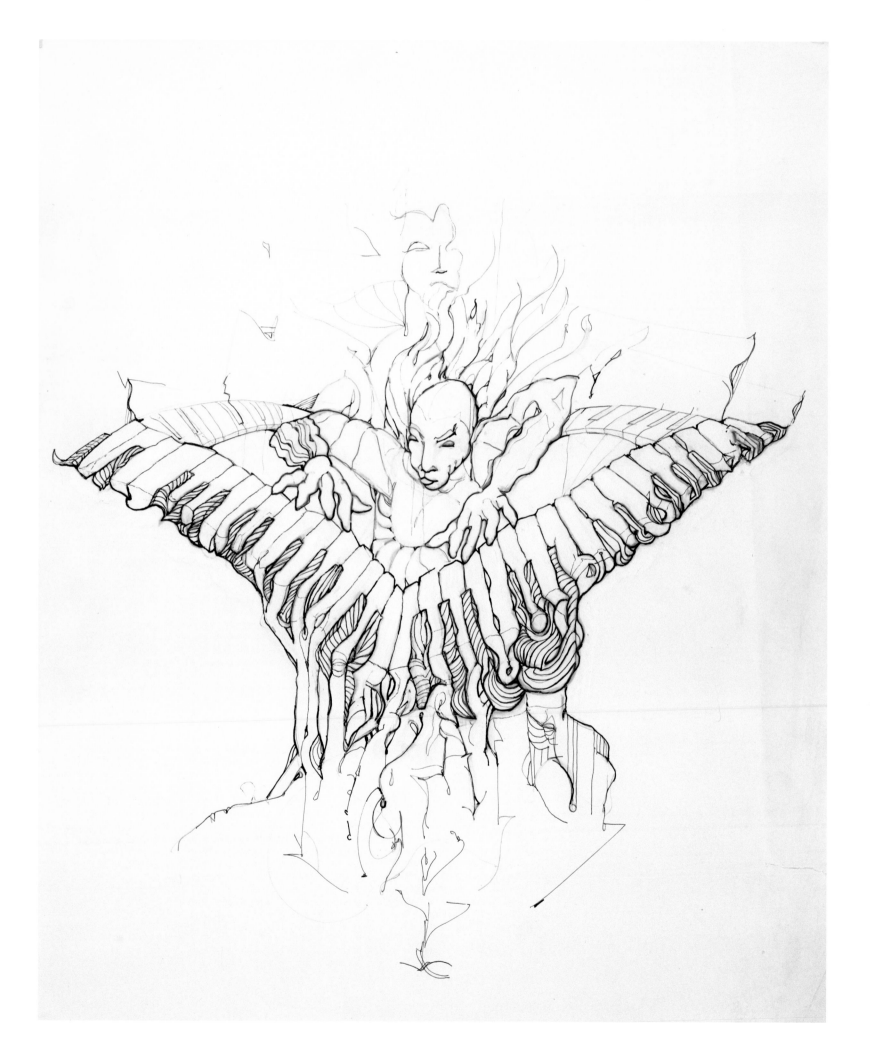

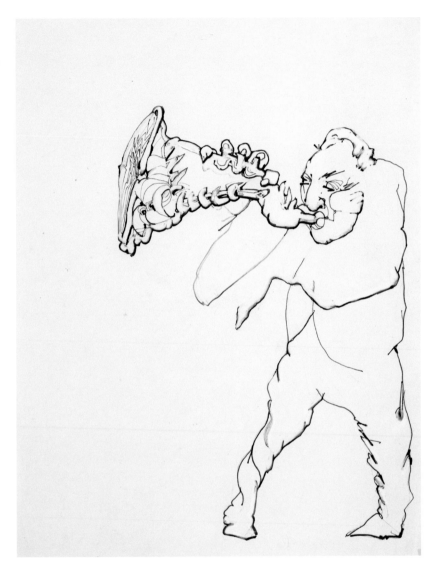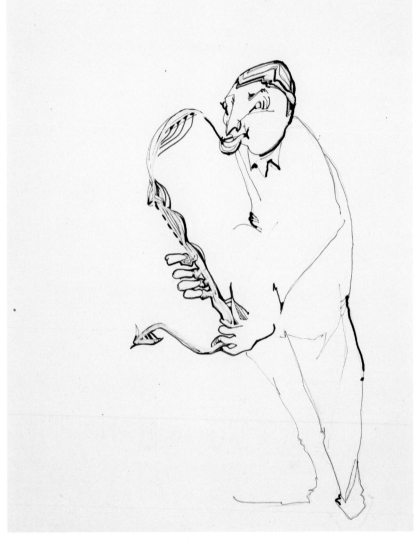

Clifford Brown, from the
Audio Talisman series, n.d.
Pen, ink, and opaque
correction fluid on paper
11 x 8½ in.
Collection of the artist

Ben Webster, from the
Audio Talisman series, n.d.
Pen, ink, and opaque
correction fluid on paper
11 x 8½ in.
Collection of the artist

Charlie Parker, from the
Audio Talisman series, n.d.
Pen, ink, and opaque
correction fluid on paper
11 x 8½ in.
Collection of the artist

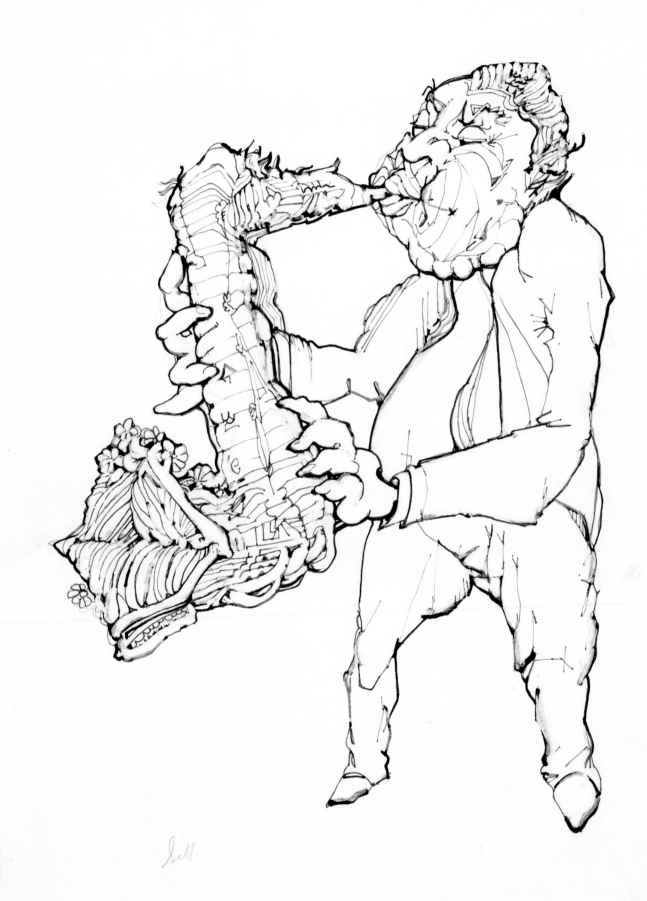

LIVING WOOD

I never reached the point that I wanted to in terms of sculpture. It requires a certain amount of space regardless of whether it is subtractive, like wood sculpture or carving, or additive. We didn't have the necessary space. Sculpture is also labor intensive, and it was always difficult for me to start and then stop. I studied wood carving here in Seattle with an Italian carver, Roberto Tacci. He had been brought

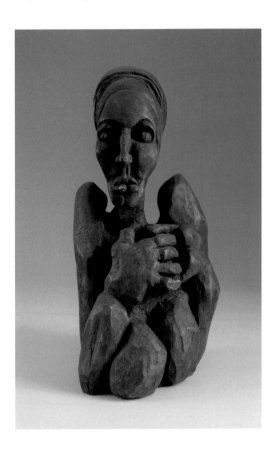

to the city by a high-end cabinetmaker on Twelfth and Pine who gave him his own studio. Roberto was teaching night classes on traditional wood carving, so that's how I learned how to sharpen tools and make ornamental studies. That's where I started really carving.

I had the good fortune to feel the impact of traditional African work that's referred to as "art" at the Portland Art Museum. I had paid some attention previously, but not enough, and I had drawn a connection between some of Picasso's painting and sculpture and traditional African work. There were a lot of European sculptors that I was fascinated by at that time: Henry Moore and Constantin Brancusi in particular. My intention was to be a hands-on, full-time sculptor; that was my first inclination. Painting and drawing were something I was doing anyway. But it came down to means and space with sculpture. I didn't take the opportunity, or make the sacrifice, to move beyond what I had in my head, to

translate it into a sculptural medium. Most of the sculptural works I made are studies. What I had in my head was monumental sculpture. I particularly liked wood and admired the work of African American sculptress Elizabeth Catlett. She was married for a while to Charles Wilbert White, who, I should say, also exerted an influence on me in terms of his line drawings. He was very popular back in the '70s.

Wood is important to me because it's alive and filled with veins.

Waiting to Scream, 1970
Carved, stained wood
16 x 8 x 9 in.
Collection of the artist

Mai Lai, 1975
Carved wood
19 x 8 x 12 in.
Collection of the artist

62

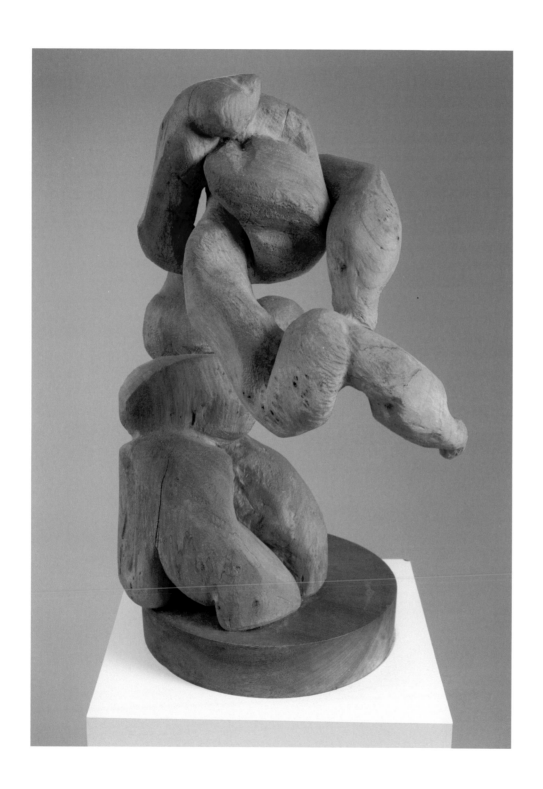

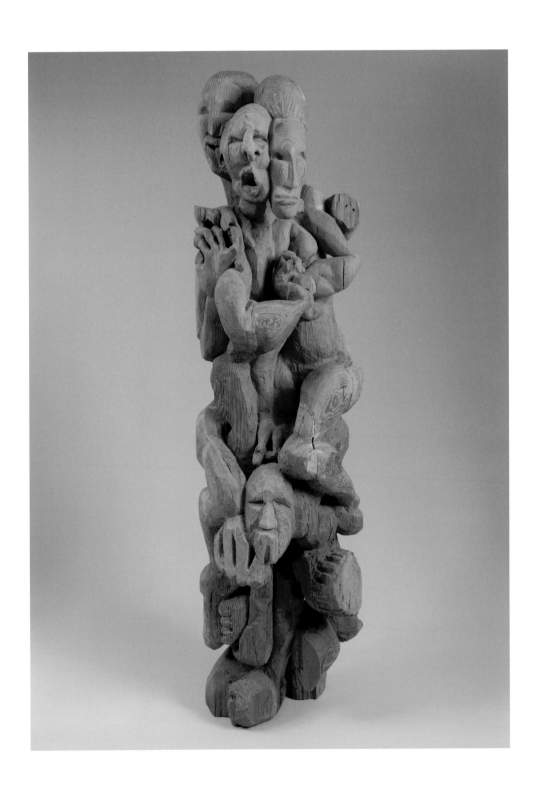

Look Them, 1975 (unfinished)
Carved wood
42 x 12 x 12 in.
Collection of the artist

64

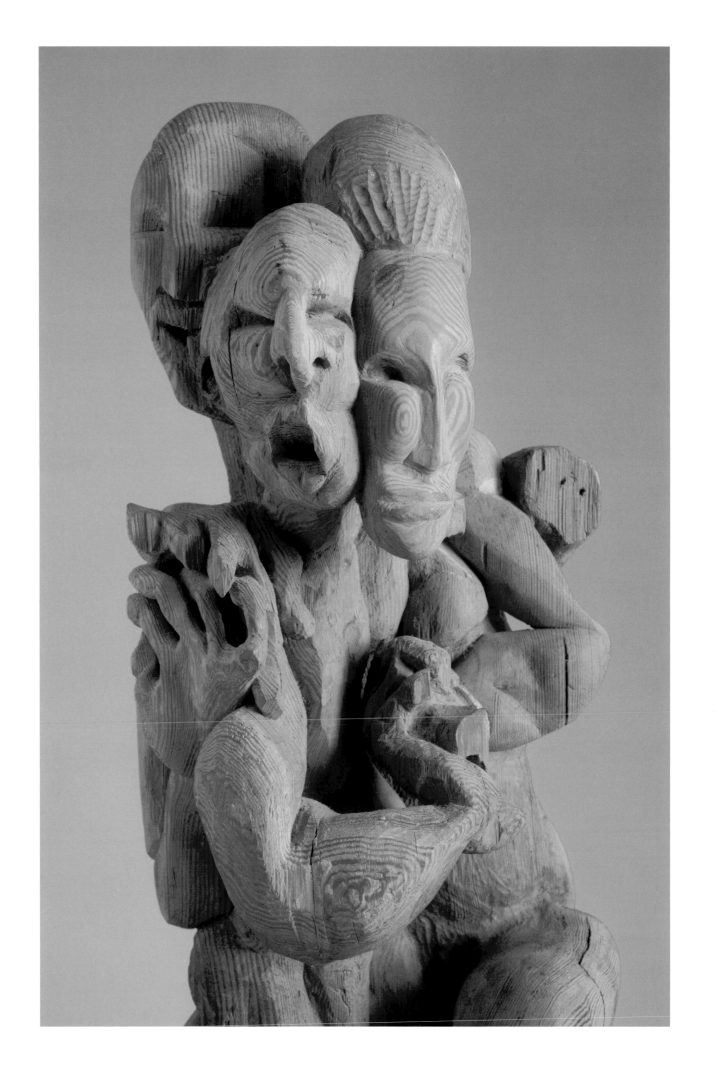

BECOMING HOME

At the time I was working on the *Omowale* mural at Medgar Evers Pool, in the early 1970s, I was naive and romantic.[7] I believed in the role of the artist. I believed in the power of a visual work to send a message. I was enamored with the Mexican tradition and with muralist Diego Rivera, among others; I think my collaborator Royal Alley-Barnes was, too. I believed in a way of life and professional sanctity then that I'll never believe in again. Once the mural was destroyed, I provided myself with a number of rationalizations and told myself that we were in good company. It was significant enough to be destroyed, I guess. At the time we were working on it, Nina Simone was singing "Young, Gifted and Black"; we took that to heart, like an anthem. I think there still is a place for some young, dedicated people full of energy to do murals.

I'll always be proud of it as a public work of art. I miss it; we put everything that we had into it. It was perhaps created at the wrong time, wrong place.

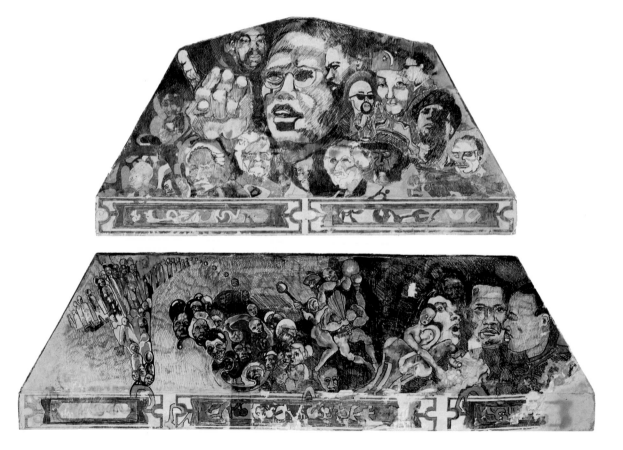

Preparatory drawings for
Omowale mural, n.d.
Mixed media on cardboard
Top: 7¾ x 15¼ in.
Bottom: 6½ x 22⅛ in.
Collection of the artist

66

The idea for the mural began when Royal and I were both teaching in the Extended Services Program (ESP) of Seattle Public Schools at the Horace Mann School at Twenty-First Avenue and East James Street. This was an alternative program for grades nine to twelve developed by the Central Area community and the school district.[8] We believed art could be used as a form of instruction and encouragement rather than as a recreational appendage to the educational process. The ESP program was set up for children and young people who had difficulty in the traditional public school format.

When the Medgar Evers Pool was built next to Garfield High School, it looked like a military bunker. To alleviate this appearance, we proposed painting a mural on the walls by the pool. Together with allies in the Seattle Board of Park Commissioners, we decided it would be best to build a wall just for the mural. When we started, the Seattle Arts Commission didn't exist. We pretty much maintained control of the process. In fact, that's how I became associated with the Black House. We wanted approval from as wide a range of community groups as possible. We went to the National Association for the Advancement of Colored People and to the Black House because it was important to have buy-in from everybody. By the time we went back to the parks board, politically, we had all the right people on board. The parks board appropriated the money and built a wall. According to one parks board member, it was supposed to last forever.

The name of the mural, *Omowale*,[9] is a Yoruba term that means "children return home," not to Africa, as some people thought, but to America in terms of its *potential* to become home. America wasn't home, and it still isn't. When we say "return home," we mean to a state of consciousness that didn't begin, or end, in slavery, which is something that tends to be a focal point when we talk about people of color. Slavery was neither the end nor the beginning; it is something that occurred, and we are still dealing with its ramifications. The last section of the mural was what we called a "honeycomb of unification and harmony." That's what we meant by "home"—self-preservation and self-determination on your own terms and not as defined by anyone else. Home in this sense is a spiritual place rather than a specific, geographic location. Black Spiritualism was represented in *Omowale* as a continuum, as an acknowledgment of what is important in the past and what is possible in the future. It was a romantic yearning for something that may or may not have ever existed.

The mural was meant to reinforce what was missing in our educational process and in our daily lives. And it is still missing. We wanted to create a new mythology out of existing elements that could have a dramatic impact; for example, a bird with wings in the shape of Africa and forms to represent the forces of oppression.

This was an exterior mural. We could only work in the spring and summer; in the winter, it was too cold. The biggest challenge was to get the paint to stay on. It took three or four summers, as I recall, to complete the mural. The reaction to the mural was mixed. Quite honestly, many people were unhappy because of its political content; we were considered militants. It was a combination of, and confluence of, events and agendas.

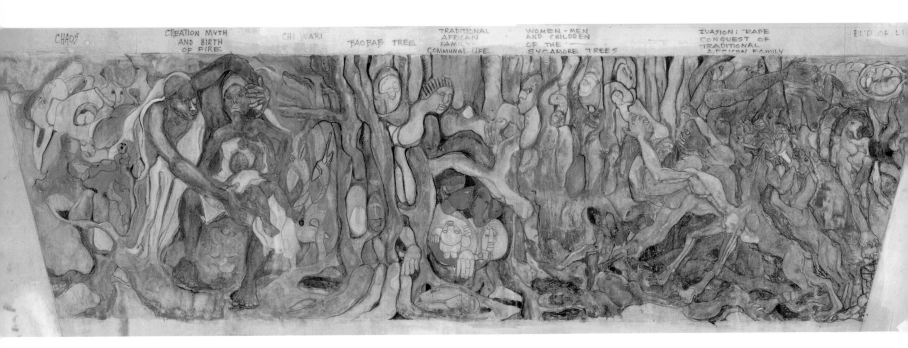

Preparatory drawings for *Omowale*
mural, early 1970s
Mixed media on paper (laminated)
Each: 10¼ x 35 in.
Collection of the artist 68

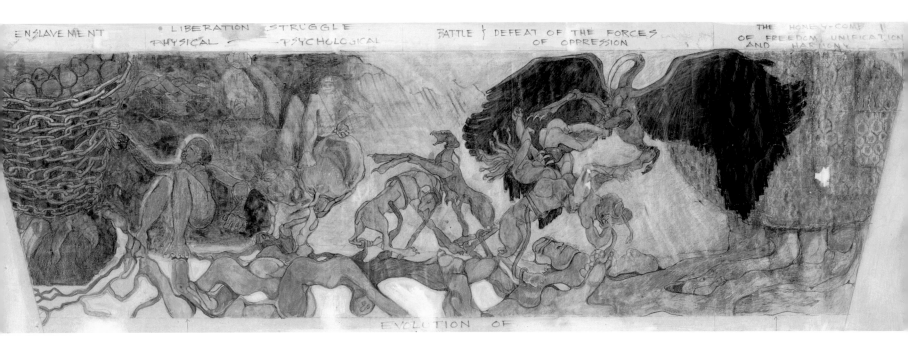

ENSLAVEMENT • LIBERATION STRUGGLE BATTLE } DEFEAT OF THE FORCES THE HONEY-COMB
PHYSICAL — PSYCHOLOGICAL OF OPPRESSION OF FREEDOM UNIFICATION
 AND HARMONY

EVOLUTION OF

THE PAST AS A PLATFORM

I don't consider the past to be a perfect panacea. I consider it a platform, a point of operation, a launch point. It's not fixed; it has movement and life. What I want to ensure is that it's acknowledged as a reality. Either we're involved in some form of progress as people, or we're not. A better level and type of interaction *is* possible, one that involves some blood, sweat, and dialogue, honest dialogue, open dialogue, which to me is preferable. We've maxed out in terms of going to war and what violence can accomplish. If everything could be accomplished with violence, the human spirit wouldn't prevail in those situations where it is outmanned and outgunned.

Sometimes we get hung up on the complications of doing things differently; we get hung up on our own arrogance, and on our ability to trick ourselves into believing that it's as difficult as we like to make it. I believe that there are enough people with common sense to make it possible to cohabit differently. You are always going to have warmongers, but it's how you balance this, not how you control that impulse.

What it finally comes down to is, if you want to dance, you've got to pay the band, as they used to say. There are some reckonings that are taking place, and that are coming about, but I don't have to worry about that because someone else is keeping track, even if it is collectively.

More civil societies have existed, and it is certainly possible that they will exist again. It's entirely possible that Atlantis existed, and I certainly believe that the Garden of Eden, such as it was, existed. But that was before motorcars and other things grabbed our attention.

AFRO-FUTURISM

The discussion around Afro-futurism is part of an ongoing evolution. Anything that encourages reading *Invisible Man* by Ralph Ellison and the works of Octavia Butler, and anything that addresses world African philosophy and its way of looking at and measuring time, is valuable. It represents an acknowledgment that no group of people can survive for thousands of years without having a very complex, multifaceted way of looking at the world and at how they got there. The ridiculous way of looking at the world and other groups of people called "race" is a function of the economic realities of the past five hundred years. We need to look at the world, and our place in it, in terms of thousands of years.

Octavia Butler is a master storyteller and one of a group of writers who contributed to the establishment and reinforcement of mythologies that exist about us. The writings of Toni Morrison are a form of science fiction. The stereotypes that exist sometimes led to us being ashamed of who we are and what we are. People of color have been talking about space for a long time and where we fit into that narrative. It is not a new subject for any group of people because, in essence, everybody is trying to find out how

they got here, what they're doing, what they're going to be doing, and what their place is. What is considered science fiction by some people might not be to others.

We are all storytellers. No matter where we look, there's a story, and somebody's trying to tell it. When I was young, I was certain about a lot of things and had a lot of things figured out. At this point in my life, my dear, I'm confused and comfortable with being confused.

THE ARTIST AS A ROLE MODEL

I don't want to be a role model. It's a term I've been hearing all my life, a term that, to me, is misused and misapplied. All people have an "artist" in themselves; self-determination and living responsibly are part of the prerequisites. Satire as a way of pointing things out, that's what I enjoy doing, no matter what format it is in. That's an important part of the role of the comedian; it's my form of commedia dell'arte, the comedy of life. But the first role of artists is to look very closely at themselves and to always remember that.

My primary role is to keep producing, and if my work does have an impact, that's a bonus. But if it doesn't, I'm not driven to continue, or to complete, a revolution. For me, it comes down to bread and wine. Whoever has the bread and wine, and can supply the bread and wine, that's the revolution, for whatever period of time. I don't want that responsibility.

Excerpted from a conversation between Curtis R. Barnes and Jo-Anne Birnie Danzker on March 25, 2014.

"BLACK ART BY AND FOR THE BLACK COMMUNITY"
THE *OMOWALE* LEGACY

In the early 1970s, the groundbreaking African American publication *Essence*, under the leadership of legendary editor in chief Marcia Ann Gillespie,[1] was one of the fastest-growing women's magazines in the United States.[2] In the July 1973 issue, an article by Alice J. Kling drew national attention to a mural in Seattle titled *Omowale*. She described the controversial mural as "a powerful work of public art that expresses, on a large scale, selected nuances from . . . the vast and varied experiences within the Black past/present/future continuum in a visually allegorical style. . . . [It] is a universal statement of shared experiences and the inevitable triumph of the Black spirit."[3] *Omowale*, Kling noted, stood "as a bold and dramatic beginning of permanent Black art by and for the Black community. It is a focal point of the city's predominantly Black central district."[4]

On Wednesday, November 20, 1974, *Omowale* was officially inaugurated in the entry court to the Medgar Evers Pool, which abutted the mural.[5] Among the speakers were artist Jacob Lawrence; landscape architect Lloyd Thorson; Virginia Van Ness, chairperson of the Board of Park Commissioners; and Samuel J. Smith, the first African American member of the Seattle City Council.[6] They honored the artists who had conceived and executed the mural—Curtis R. Barnes and Royal (Pauline) Alley-Barnes—and recognized assistant artist Wayne Wells.[7] The following day, the *Seattle Times* published a photograph of *Omowale* and noted that it had been funded by the Seattle Arts Commission.[8] Additional support for the construction of the mural had been provided by Pacific Northwest Bell Telephone Company[9] and President Lyndon Johnson's Model Cities program.[10]

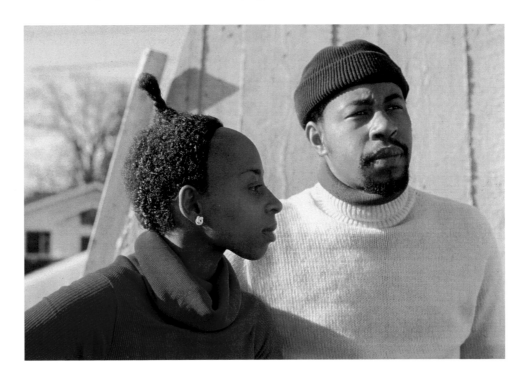

Photograph of Royal Alley-Barnes
and Curtis R. Barnes, 1973
Collection of the artist

Photograph of *Omowale* mural,
early 1970s
Collection of the artist 72

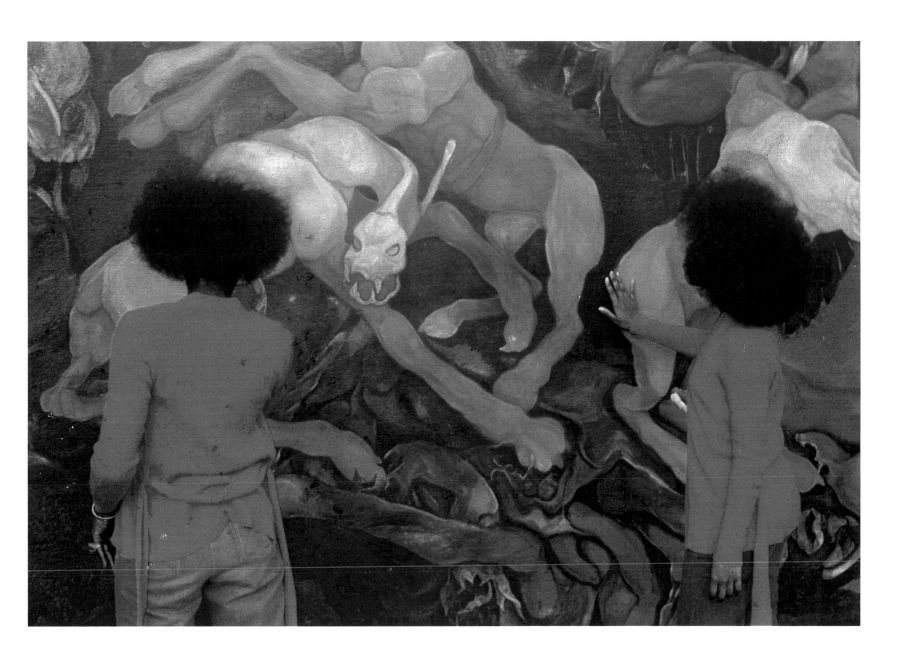

Within a few years, however, supporters of the project were increasingly concerned about the condition of the mural.[11] In August 1979, Alan W. Barnett, professor of humanities at San José State University, visited Seattle to undertake research for his influential 1984 publication *Community Murals: The People's Art*. In a letter addressed to Seattle mayor Charles Royer,[12] Barnett described *Omowale* as

> one of the finest and most professional works done anywhere. . . . However, what also struck me was the deterioration that the mural has suffered. Although the color is still beautiful, some of the pigment has been pulled off, and there is bad staining that can be cleaned. Thus there is an urgent need for some repainting and sealing, which never seems to have been done. Also, an explanatory plaque would be helpful. . . . I would think that Seattle would want to restore *Omowale* so that it can be appreciated by local people and visitors alike.[13]

By the mid-1980s, a committee for the restoration of the mural had been established under the leadership of distinguished educator Dr. Millie L. Russell. In her correspondence with the Seattle Arts Commission and Seattle Parks and Recreation, Russell requested support for covering the costs of repair. As early as 1985, however, it had become clear that the Seattle Arts Commission had not anticipated that *Omowale* would last longer than five years. While the executive secretary of the commission stated that proposals for a new artwork at the same location would be welcomed,[14] there was no indication that funds would be made available for the restoration of *Omowale* or that the goal of preserving it as a permanent work of public art would be embraced.

Among those who expressed their support for restoration of the mural in 1986 were philanthropist and collector Anne Gerber, who described *Omowale* as "an important symbolical reference in the neighborhood";[15] representatives of the School of Art at the University of Washington;[16] and Hank Roney, president of the Northwest chapter of the National Association of Minority Contractors, who stressed the importance of this "outstanding artwork . . . created and executed by black artists from within the community."[17] Dr. Olvin Moreland, Jr., president of Black Professional Educators of Greater Puget Sound, noted the significance of *Omowale* to the Central District community: "The need to preserve the artifacts of the African-American culture is of paramount importance to us as well as continuing to develop excellence within our community for our youth to see and to emulate as positive role models."[18]

Other supporters included ROOTS (Relatives of Old-Timers), the Seattle Urban League, and the Black United Clergy for Action. The president of the Seattle chapter of the National Association for the Advancement of Colored People wrote, "We reached the top as a community when the Mural was 'active.' It must be more than a memory for our young people."[19] Alan W. Barnett, whose book on community murals had by then become a standard on the topic, reiterated his belief that *Omowale* was one of the finest murals to have been created in the United States in the preceding twenty years.[20] Charles P. Huey, cofounder of the Central Area Youth Association and chairman of the Washington State Human Rights Commission, agreed and wrote eloquently of the role that *Omowale* played in the life of the city:

The mural is a "port of call" for Afro-Americans. It is our sister for all of the past Africaness that we have drawn from as Afro-Americans. . . . The fact that we are a people with a deep knowledge and appreciation for Africa and America is something that we are aware of and that needs to be brought to the public eye. Omowale does this. It talks about from whence we came, where we have been and hopefully how we will go forward. We must bring our history to all people.[21]

Although *Essence* had heralded *Omowale* in 1973 as the "beginning of permanent Black art by and for the Black community," twenty years later, in 1993, the mural faced imminent removal. Artist Marita Dingus appealed to Seattle Parks and Recreation to preserve *Omowale*:

I grew up watching it be painted. Our community has an artistic heritage that is directly tied to this first public work of art. Seattle does not talk about tearing down other historical sites or artistic treasures. This is no different.[22]

Despite such passionate appeals and numerous letters of petition from concerned citizens, the mural was destroyed in 1995. As Curtis Barnes notes in this volume (p. 66):

At the time I was working on the *Omowale* mural at Medgar Evers Pool, in the early 1970s, I was naive and romantic. I believed in the role of the artist. I believed in the power of a visual work to send a message. . . . I believed in a way of life and professional sanctity then that I'll never believe in again. Once the mural was destroyed, I provided myself with a number of rationalizations and told myself that we were in good company. It was significant enough to be destroyed, I guess. At the time we were working on it, Nina Simone was singing "Young, Gifted and Black"; we took that to heart, like an anthem. I think there still is a place for some young, dedicated people full of energy to do murals.

Maikoiyo Alley-Barnes, the son of Curtis R. Barnes and Royal Alley-Barnes and a practicing artist, describes himself as a bearer of the *Omowale* legacy. That legacy has remained intact in the work of Curtis Barnes until the present day. It is evident in the allegories and morality tales depicted in his paintings and works on paper, and in his nuanced depictions of vast and varied experiences within the African American "past/present/future continuum," as Alice J. Kling noted in 1973. More than forty years after the completion of *Omowale*, Barnes remains insistent in his belief in "a state of consciousness that didn't begin, or end, in slavery," in his rejection of institutionalized racism, and in a realization of a self-determined present and future. These themes continue as both the subject and the aspiration of his work.

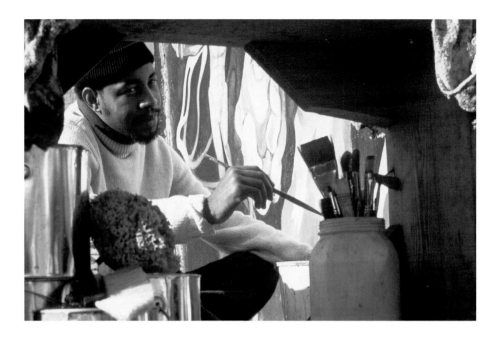

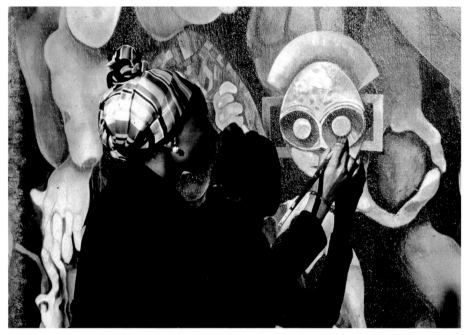

Photograph of Curtis R. Barnes
painting *Omowale* mural, early 1970s
Collection of the artist

Photograph of Royal Alley-Barnes
painting *Omowale* mural, early 1970s
Collection of the artist

Photograph of Curtis R. Barnes and
Royal Alley-Barnes, early 1970s
Collection of the artist

Photograph of Curtis R. Barnes
painting *Omowale* mural, early 1970s
Collection of the artist

Pages 78–81
Photographs of the *Omowale* mural,
early 1970s
Collection of the artist

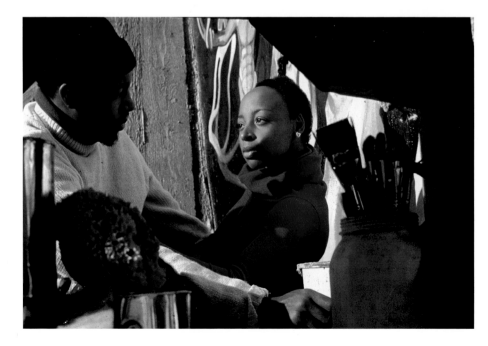

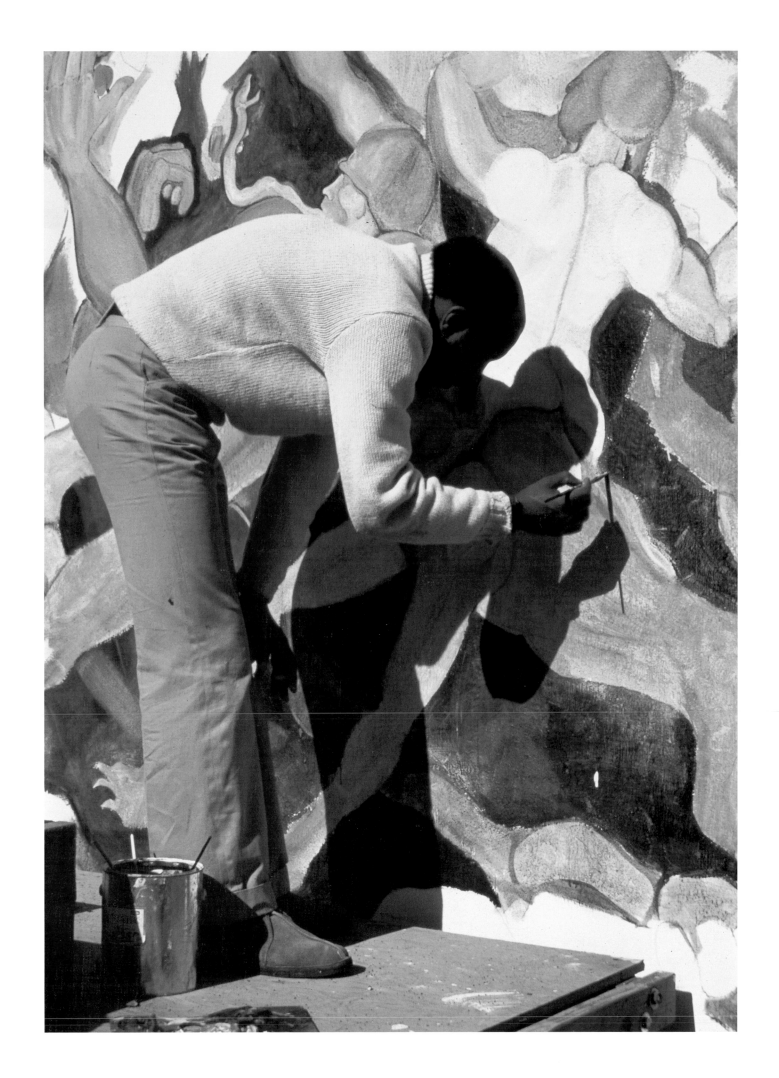

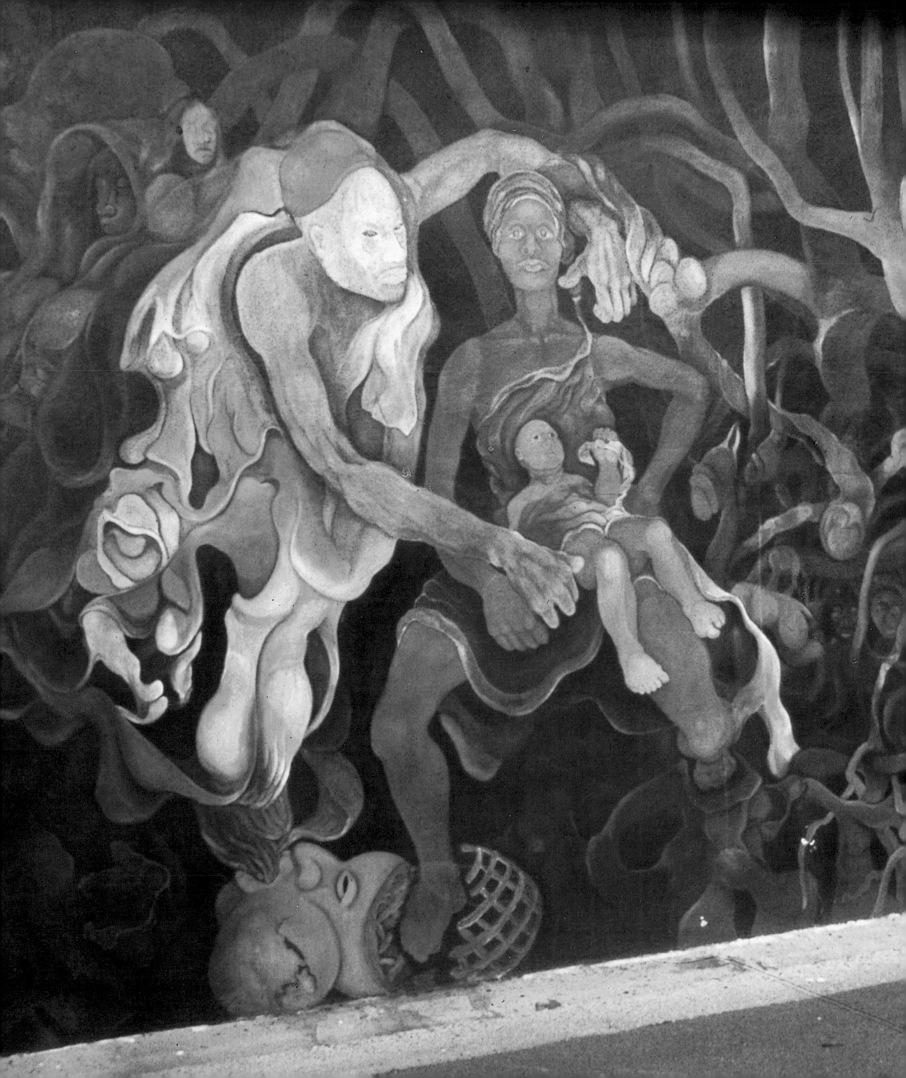

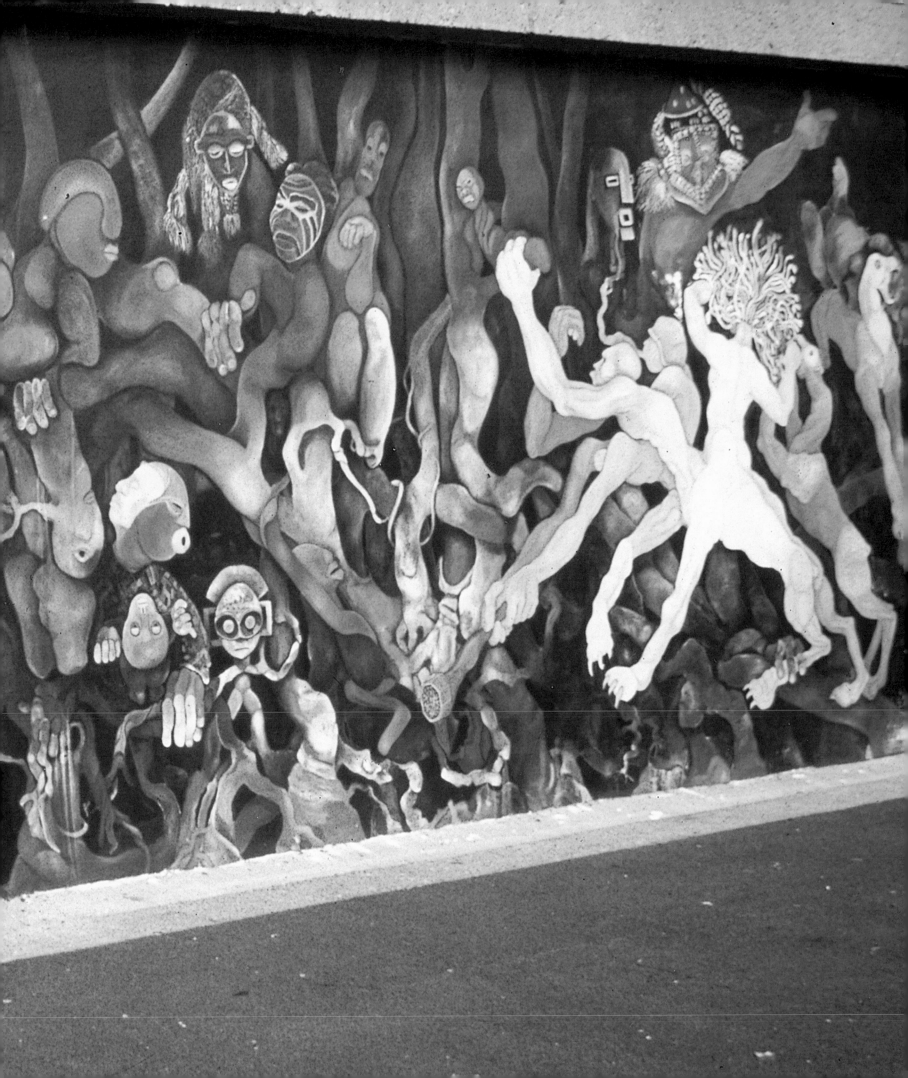

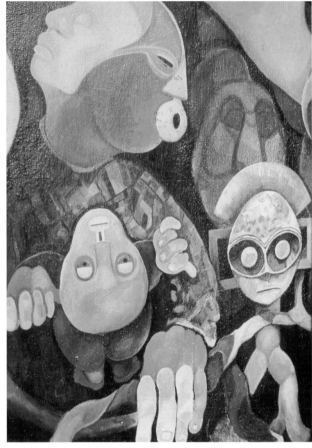

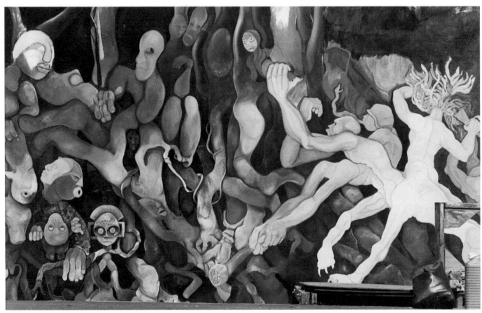

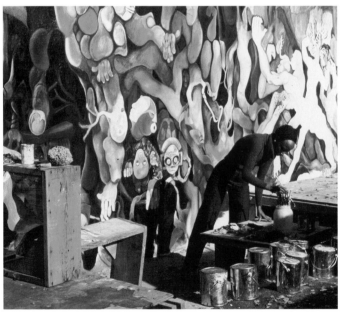

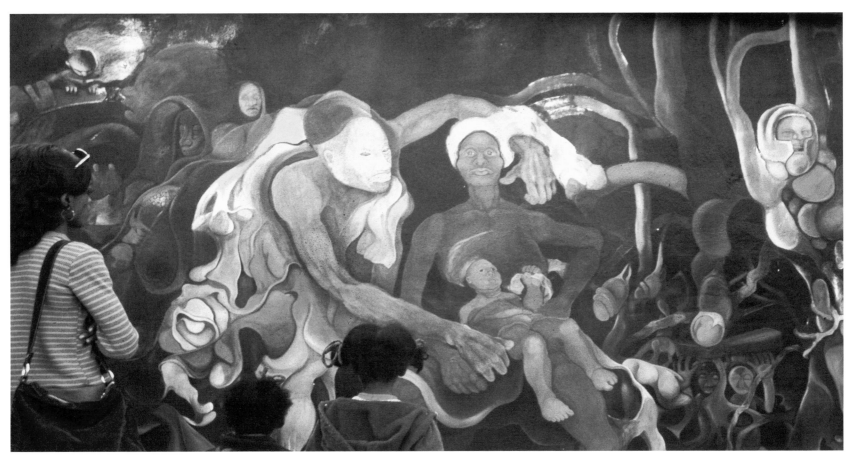

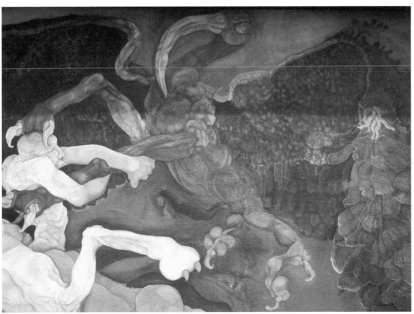

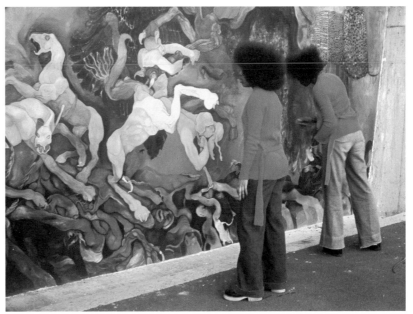

CURTIS R. BARNES, IN CONVERSATION

1 The Henry L. Yesler Memorial Library, today the Douglass-Truth Branch of the Seattle Public Library.

2 Muhammad Ali (b. 1942) was world heavyweight champion when he became a conscientious objector, refusing induction into the military on religious grounds, during the Vietnam War.

3 Paul Robeson (1898–1976) was an athlete, stage and film actor, singer, and international civil rights advocate.

4 Jackie Robinson (1919–1972), the first African American to play in major league baseball, testified at a hearing of the House Un-American Activities Committee, which was investigating Robeson, in 1949.

5 The Black Panther Party newspaper was published from 1968 to 1973; *Muhammad Speaks* (now *Muslim Journal*) began publication in 1960.

6 McCann's signature song, "Compared to What," was written by Gene McDaniels.

7 Medgar Evers Pool, operated by Seattle Parks and Recreation, is located on Twenty-Third Avenue, next to the Garfield Community Center.

8 "It provided more individualized instruction and attention than was possible in the regular school setting. Additionally, it gave students who had dropped out, or who had been suspended, a chance to continue their education. In 1975, ESP became GAP (the Garfield Alternative Program). That September, an alternative high school called Nova joined GAP at Mann. Summit K-12 was at Mann from fall 1977 through spring 1979, when it moved to Colman." "Seattle Public Schools, 1862–2000: Horace Mann School," HistoryLink.org Essay 10553, accessed March 2014, http://www .historylink.org/index.cfm?DisplayPage=output .cfm&file_id=10553.

9 The honorific title Omowale was given to Malcolm X by the Nigerian Muslim Students Association.

JO-ANNE BIRNIE DANZKER, "BLACK ART BY AND FOR THE BLACK COMMUNITY"

1 See *The HistoryMakers,* biography of Marcia Ann Gillespie, accessed April 2014, http://www .thehistorymakers.com/biography /marcia-ann-gillespie.

2 Ibid. See also Wikipedia: "Edward Lewis, Clarence O. Smith, Cecil Hollingsworth, Jonathan Blount and Denise M. Clark founded Essence Communications Inc. (ECI) in 1968, and it began publishing *Essence* magazine in May 1970." *Wikipedia,* s.v. "Essence (magazine)," accessed April 2014, http://en.wikipedia.org/wiki /Essence_(magazine).

3 Alice J. Kling, "Omowale: The Black Experience," *Essence* 4, no. 3 (July 1973): 50–51, 64, 67.

4 Ibid.

5 The pool, operated by Seattle Parks and Recreation, is located on Twenty-Third Avenue, next to the Garfield Community Center. It was named in honor of Medgar Wiley Evers (1925–1963), an African American civil rights leader from Mississippi who was murdered by Byron De La Beckwith. The pool was built with Forward Thrust bonds. It was the first to be constructed with "these levy funds and its 'unique' architectural design immediately started causing problems and construction delays for the contractors." Seattle Parks and Recreation, "Seattle Pool History," accessed April 2014, http:// seattlepools.org/wp-content/uploads/file /Seattle%20Pool%20History.doc.

6 Sam Smith (1922–1995), Seattle City Councilman, Seattle Municipal Archives, accessed April 2014, http://www4.seattle.gov/CityArchives /Exhibits/Sam_Smith/.

7 See *Omowale* mural dedication program and City of Seattle memorandum from Milo Johnstone to all participants, "Program Schedule for 'The Omowale Mural,'" November 15, 1974, Curtis R. Barnes archive, Seattle.

8 Newspaper clipping, Barnes archive.

9 Pacific Northwest Bell Telephone Company was formed in 1961 and ceased operations in 1991. The City of Seattle's Youth Division was also among the mural's supporters.

10 Alan W. Barnett, *Community Murals: The People's Art* (Philadelphia: Art Alliance Press; New York: Cornwall Books, 1984), 117. D. Bradford Hunt noted, "Model Cities, an element of President Lyndon Johnson's War on Poverty, was an ambitious federal urban aid program that ultimately fell short of its goals. Passed by Congress in 1966 but ended in 1974, Model Cities originated in several concerns of the mid-1960s. Widespread urban violence, disillusionment with the Urban Renewal program, and bureaucratic difficulties in the first years of the War on Poverty led to calls for reform of federal programs. The Model Cities initiative created a new program at the Department of Housing and Urban Development (HUD) intended to improve coordination of existing urban programs and provide additional funds for local plans. The program's goals emphasized comprehensive planning, involving not just rebuilding but also rehabilitation, social service delivery, and citizen participation." D. Bradford Hunt, "Model Cities," *The Electronic Encyclopedia of Chicago* (Chicago: Chicago Historical Society, 2005), accessed April 2014, http://www.encyclopedia.chicagohistory .org/pages/832.html.

11 According to a letter from Millie L. Russell, chairperson, Omowale Mural Restoration Committee, to Carl J. Petrick, executive secretary, Seattle Arts Commission, dated October 11, 1985, the deterioration was due to vandalism and lack of maintenance. Barnes archive.

12 Charles T. Royer (b. 1939) was mayor of Seattle from 1978 to 1990.

13 Alan W. Barnett, letter to Mayor Charles Royer, August 19, 1979, Barnes archive.

14 Carl J. Petrick, executive secretary, Seattle Arts Commission, letter to Paul Dusenbury, October 7, 1985, Barnes archive.

15 Anne Gerber, letter to Seattle Arts Commission, June 3, 1986, Barnes archive.

16 School of Art, University of Washington, letter to Seattle Arts Commission, June 3, 1986, Barnes archive.

17 Hank Roney, letter to Dr. Millie Russell, June 3, 1986, Barnes archive.

18 Dr. Olvin Moreland, Jr., letter to Dr. Millie Russell, June 2, 1986, Barnes archive.

19 Lacy Steele, letter to Dr. Millie Russell, June 2, 1986, Barnes archive.

20 Alan W. Barnett, letter to Dr. Millie Russell, May 29, 1986, Barnes archive.

21 Charles P. Huey, letter to Mrs. White, May 12, 1986, Barnes archive. See Carole Beers, "Charles P. Huey, an Advocate for Youth, Families, Community," *Seattle Times,* August 5, 1994, accessed April 2014, http://community .seattletimes.nwsource.com/archive/?date=19940 805&slug=1923785.

22 Marita Dingus, letter to Joy Okasaki, project manager, Seattle Parks and Recreation, December 14, 1993, Barnes archive.

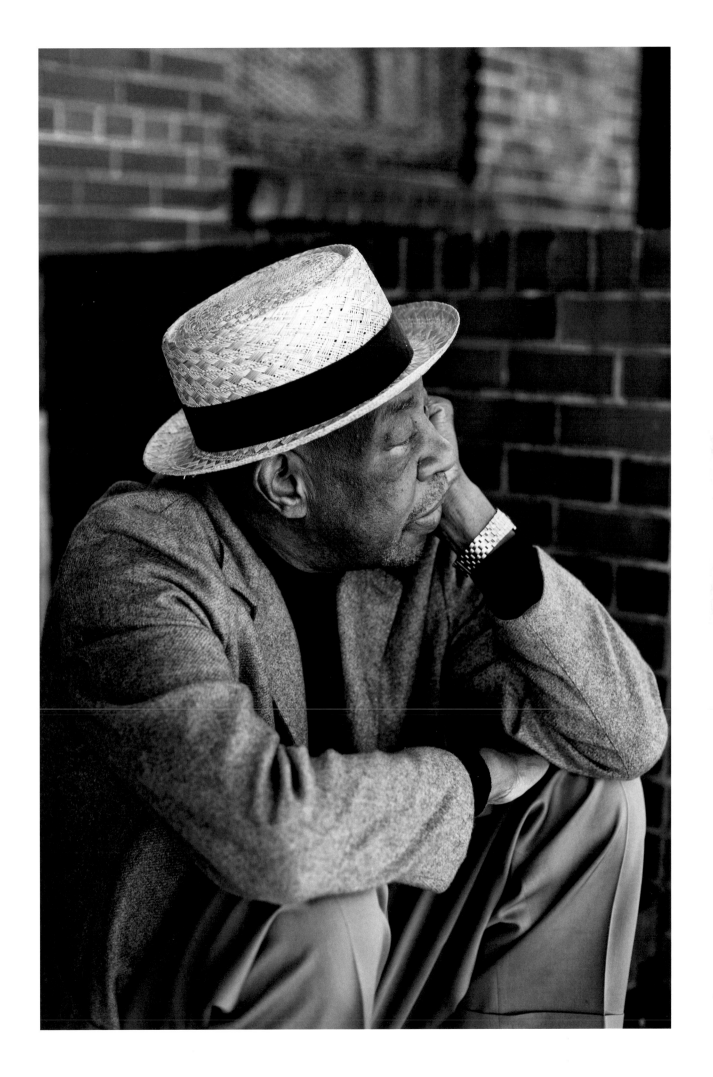

This catalogue has been published on the occasion of the exhibition *The Unicorn Incorporated: Curtis R. Barnes* at the Frye Art Museum, Seattle, from June 14 to September 21, 2014.

The Unicorn Incorporated: Curtis R. Barnes organized by the Frye Art Museum and curated by Jo-Anne Birnie Danzker.

The exhibition and catalogue are funded by the Frye Foundation with the generous support of David and Kristi Buck and Frye Art Museum members and donors. Sponsorship is provided by the Seattle Office of Arts & Culture. Seasonal support is provided by 4Culture and ArtsFund. Media sponsorship of the exhibition is by *City Arts*.

EXHIBITION
Curator: Jo-Anne Birnie Danzker
Deputy Director, Collections and Exhibitions: Scott Lawrimore
Project Coordinators: Tina Lee and Amelia Hooning
Collections Manager/Registrar: Cory Gooch
Collections Assistant: Jess Atkinson
Collections Intern: Nives Mestrovic
Exhibition Design: Shane Montgomery
Exhibition Preparation: Mark Eddington, Ken Kelly, Elizabeth Mauro

CATALOGUE
Editor: Jo-Anne Birnie Danzker
Deputy Director, Communications: Jeffrey Hirsch
Publication Coordinators: Tina Lee and Amelia Hooning
Copyeditor: Laura Iwasaki
Proofreader: Roberta Klarreich
Photography: Richard Nicol

Design: Victoria Culver

Printed in Canada by Hemlock Printers
Color management by Hemlock Printers

Library of Congress Control Number: 2014939723

ISBN: 978-0-9624602-8-9

Frye Art Museum
704 Terry Ave.
Seattle, WA 98104
USA
www.fryemuseum.org

Cover
Looking for Open Windows among the Shadows of the Cocaine Envelope (detail), 1980
Mixed media on canvas
47 x 37 in.
Collection of the artist

Title page
Self-Portrait, n.d.
Pen and ink on paper
12 x 9 in.
Collection of the artist

Page 2
Hummingbird (detail), 1976
Pencil and conté on paper
14 x 9½ in.
Collection of the artist